PAINTING THE DAKOTA

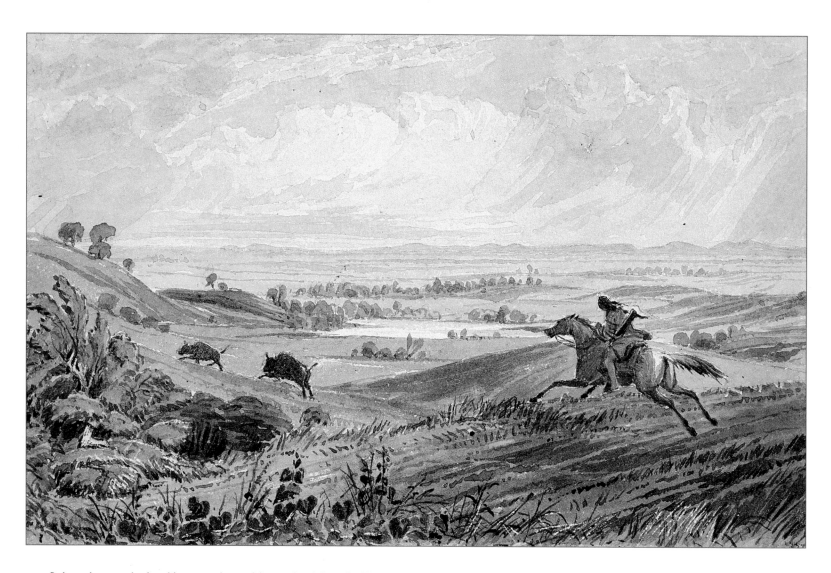

Dakota hunter chasing bison on the prairie south of Fort Snelling

PAINTING THE DAKOTA

Seth Eastman at Fort Snelling

by Marybeth Lorbiecki

Foreword by Lori K. Crowchild

Paintings and drawings by Seth Eastman

Afton Historical Society Press

Afton, Minnesota

For Dakota youth

Note to Readers: The Dakota calendar described in the chapter "Dakota Days" is one version. There are between twelve and thirteen cycles of the moon in each year, so "moons" do not correspond exactly to months. Also, there were sometimes more than one name for a particular moon.

JACKET ART: (front) *Indians Traveling,* (back) *Indian Burial Ground;* paintings by Seth Eastman

Designed by Mary Susan Oleson
Edited by Sarah P. Rubinstein

Library of Congress Cataloging-in-Publication Data

Lorbiecki, Marybeth.
 Painting the Dakota: Seth Eastman at Fort Snelling / by Marybeth Lorbiecki; paintings and drawings by Seth Eastman.
 p. cm.
 ISBN 1-890434-32-9
 1. Eastman, Seth, 1808-1875. 2. Dakota Indians--Portraits. 3. Dakota Indians--Pictoral works. 4. Artists--Minnesota--Fort Snelling--Biography. 5. Dakota Indians--Social life and customs. I. Eastman, Seth, 1808-1875. II. Title.

E99. D1 E23 2000
759.13--dc21
[B] 00-040161

Printed in Canada

✤ The Afton Historical Society Press publishes exceptional books on regional subjects.

W. Duncan MacMillan
President

Patricia Condon Johnston
Publisher

Afton Historical Society Press
P.O. Box 100 Afton, MN 55001
1-800-436-8443
aftonpress@aftonpress.com
www.aftonpress.com

CONTENTS

Foreword

IN AND AMONG THE VALLEYS and woodlands of the Mississippi and Minnesota Rivers, Seth Eastman met the native people who had lived in the area for many generations. These lands were the home of the people known as the Dakota and the Ojibwe. Here they lived and moved with the plant and animal life that supported their existence as naturally as the seasons move over the earth.

Contact with early traders, missionaries, and the military brought many changes to Native Americans. Some Natives felt those things non-Natives had to offer, such as horses, guns, and tools, were helpful at best and at the least, unavoidable. Other Natives felt strongly that they should shun these intruders and their ways. Regardless, by the time Eastman arrived at Fort Snelling, the lives of the Dakota and Ojibwe were changing dramatically.

Disrespect and disregard for Native people and culture accompanied the non-Native desire for control over Dakota lands and its inhabitants. After a time, the Dakota were not offered a choice in the changes to their lives. Rather, they were forced to accept which lands they would call home, where and how they would be educated, and how they would worship. These and other unfair conditions and domination led to the near annihilation of all Native Americans throughout the United States.

On the one hand, Seth Eastman's arrival in the area that was to become Minnesota was unfortunate. His presence can be considered a symbol of the losses suffered by Native Americans. On the other hand, his work to record his observations and understanding of the Dakota helps us today. His watercolor

paintings are beautiful pieces of art and they give all of us, Natives and non-Natives, an appreciation of Dakota life during a time of transition and upheaval.

The Dakota people survived the control imposed upon them by non-Natives. Many of the Dakota descendants of Wakaninajinwin (Stands Sacred) and Seth Eastman continue to live in and around Dakota communities in Minnesota and South Dakota. The strength and courage of the Dakota ancestors carried them through difficult and often dangerous times. Their sacrifice has allowed today's Dakota people to be a positive force in the continuation, restoration, and definition of Dakota culture.

It is my hope that *Painting the Dakota* will inspire readers to learn more about Native Americans. In understanding more about this country's Native people, their successes, and their tragedies, perhaps we can eliminate the ignorance that often leads to racism directed at Native Americans. While Native Americans have shown an ability to survive the most terrible assaults on their people, their languages, and their cultures, they still struggle for equality and acceptance in today's world. As long as there continues to be injustice directed at Native Americans, the tragedies of the past are never too far distant.

Lori K. Crowchild
Descendant of Wakaninajinwin and Seth Eastman

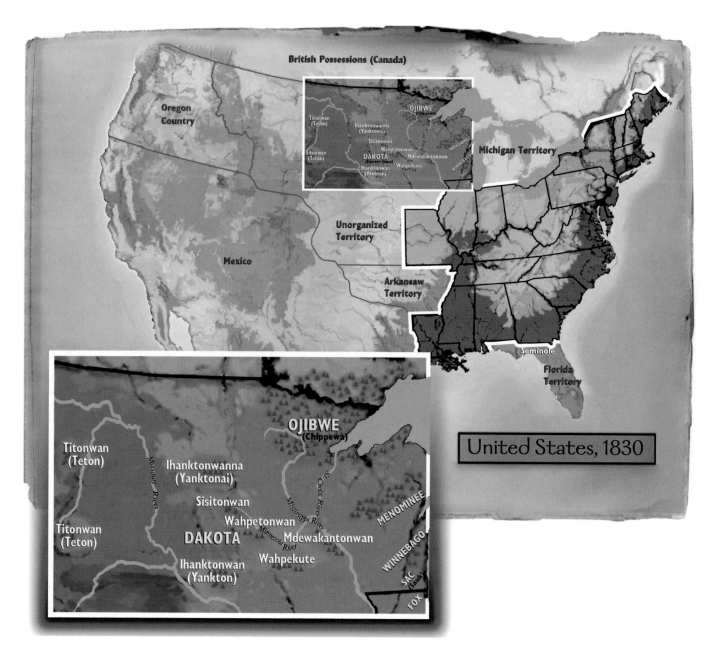

Map of United States in 1830 with the states and territories, showing the locations of the individual eastern and western bands of Dakota as well as those of the Ojibwe, Winnebago, Sac (Sauk), and Fox Indians.

HIS ORDERS SENT HIM WEST, past the end of the United States, to Indian country. He was assigned to a frontier fort in a place now known as Minnesota.

At Fort Snelling, Seth Eastman found himself in the lands of the eastern Sioux. They called themselves the Dakota.

In 1830, only fur traders, small companies of soldiers, and a few other adventurers had ever ventured this far from "civilized society." Tales had come back about the mammoth buffalo, the wild animals, the woods, waterfalls, and prairies, the Indians dressed in hides and feathers.

Myths grew. In these stories, the many Indian nations blended into one people—the Indians. Some painters, like George Catlin and Karl Bodmer, went west to paint them. They traveled from one Indian nation to the next, painting mostly portraits of chiefs.

Seth Eastman was different. At Fort Snelling, he came to know one particular Indian nation well. He was not interested in painting chiefs. He painted ordinary Dakota men and women doing everyday things. He showed how they lived, how they worked, how they played. He showed them as a part of the land they lived in.

By capturing what he saw, Seth Eastman created a record in pictures unlike anyone else's. No other painter of Indians left behind such realistic snapshots of the "Sioux" and life before reservations.

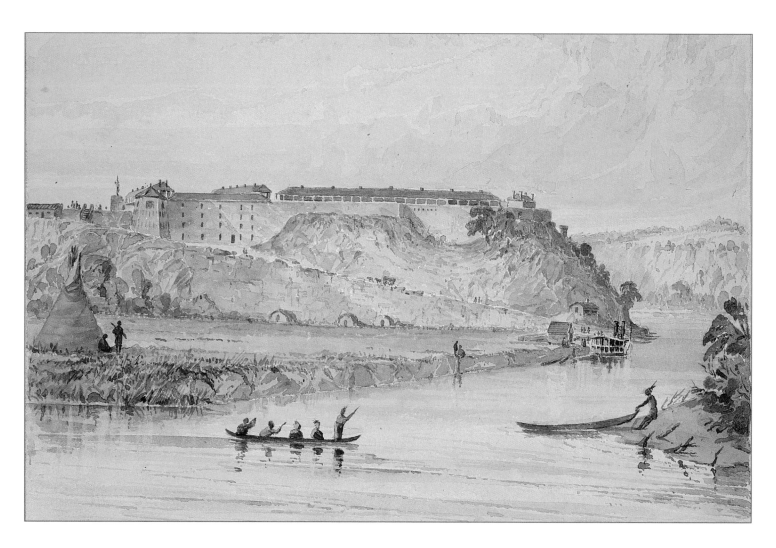

Built from native limestone at the meeting of the Mississippi and Minnesota Rivers, Fort Snelling was the finest fort in the American West.

A Frontier Fort

February 2, 1830 to November 25, 1831

SETH EASTMAN looked up the snow-covered bluff and saw the fort's flag waving in the February winds. He had arrived.

Fort Snelling hunched its big-walled shoulders over the meeting of the Mississippi and St. Peter's (today called the Minnesota) Rivers. An army guardsman in red plumed hat and dark wool coat stood at the gate to check passports and military papers. Twenty-two-year-old Seth Eastman reported for duty: second lieutenant, Company I, First Infantry, United States Army.

At this point in his career, 1830, the army paid little attention to the fact that Lieutenant Eastman could draw well. He was just one more young officer to watch over the fort's soldiers and wait out the winter. And he was the lowest possible officer, only six months out of school.

Seth had just come 150 miles up the ice-lined Mississippi, from Fort Crawford in Wisconsin Territory. He had passed through places where a call like an owl's hoot or a jay's screech could mean someone was watching. A Dakota, Fox, Sac, or Winnebago scout might be listening, waiting, deciding whether or not to let strangers pass.

These were Indian lands. The United States only owned the grounds around the fort. It sat on a military base of 100,000 acres that had been purchased from a few Dakota leaders in an 1805 treaty. The troops at the fort were assigned to protect the frontier against British troops that might invade from Canada.

The fort's soldiers were also to protect the American fur trade from European traders. Fur trading was big business, the biggest on the frontier. Fur coats and hats (especially those made of beaver) were a sign of fashion and wealth on the East Coast and in Europe. Traders exchanged goods for furs with Indian hunters. American traders did not want anyone else working in their territory. So the army was to arrest or chase off foreign fur dealers.

Beyond this, the troops at Fort Snelling were ordered to keep the peace between the Dakota and the Ojibwe. This was the real job.

Hatred oozed between these two woodland nations like bad blood between brothers. The eastern Dakota lived in the leafy shelter of the Big Woods—in what is now western Wisconsin, central Minnesota, northern Iowa, and the eastern Dakotas.

The Ojibwe (called the Chippewa by the soldiers and Dakota) claimed the North Woods—the pine and birch forests around the Great Lakes of Michigan, Huron, and Superior.

The Dakota and Ojibwe had once been allies against the Fox and Sac (also called Sauk) nations. But the fur trade had thrown off the balance. Both the Dakota and the Ojibwe wanted the modern technology and conveniences the traders brought, especially the kettles, scissors, and knives, muskets and ammunition. So the Dakota and Ojibwe competed for traders' favors.

Fur animals grew scarce from overhunting. By the late 1820s, beaver and otter pelts (worth about $3 apiece) were rarely traded because there were so few. Muskrat (or rat) pelts (worth about 20 cents apiece) became the normal fur of exchange.

The Dakota and the Ojibwe needed more and fresher hunting grounds. The woodland Dakota inched their way west into the prairies of the western Dakota. The Ojibwe moved southwest into Dakota hunting areas.

The nations clashed around Fort Snelling and the St. Peter's River Valley.

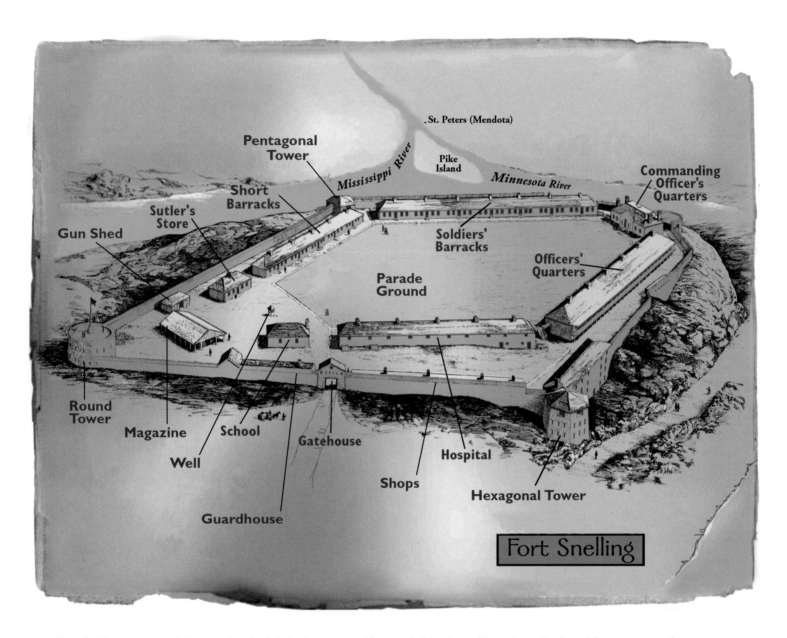

Fort Snelling was a walled town that included almost everything needed by its residents: barracks for soldiers, more spacious quarters for officers, and a stately stone house for the commander. There was a store, supply warehouse, hospital, schoolroom, library with a good collection of newspapers and books, and an office for the paymaster. Lining the three-foot-thick stone walls were the workshops of the carpenters, blacksmiths, and wheelwrights as well as the guardhouse and jail, and storage for arms and ammunition.

Prairie back of
Fort Snelling

This is where the North Woods met the Big Woods at the edge of the
Prairies. The soldiers at the fort stood like referees, trying to stop the
deadly sparring.

The St. Peters Indian agent, Major Lawrence Taliaferro, was a go-
between, working to convince the Dakota and Ojibwe to make promises
of peace and keep them. Taliaferro held ceremonial meetings with the
chiefs and leaders in the the log Council House that stood just beyond the
fort's potato fields.

Within Fort Snelling's stone walls, fifes and drums announced five roll
calls daily, work assignments, dress parade in the evening, and inspections
before nightly tattoo. Outside lay the stables. Yet horses were of little use in
the deep snowdrifts that settled on the prairies from December to March.

The winter frontier offered Eastman and the other men frozen

boredom. A doctor at the fort in the 1830s described February: "We have all been most of the month shut up in the fort and confin'd to our rooms owing to the excessive cold." The snow, ice, and high-top winds hemmed them all in until the rivers cracked and the prairie snows melted.

Even the mail came and went only once a month, if that. A soldier wearing snowshoes had to carry it. It could take from three to six months for a letter to travel from Fort Snelling to Eastman's family back on the East Coast.

Seth had grown up in Brunswick, Massachusetts (now part of Maine). Born January 24, 1808, Seth was the eldest of Robert and Sarah Lee Eastman's thirteen children. Robert was a watchmaker, inventor, farmer, and former soldier. He had hoped Seth would attend Bowdoin College in Brunswick where he had friends among the faculty. But his son showed he had a will of his own.

In June 1824, sixteen-year-old Seth Eastman set off for New York State. His destination was the United States Military Academy at West Point, on the Hudson River.

A less than average student, it took Eastman five years to graduate instead of the usual four. His highest credit points came in conduct—following the rules and handling himself well. He did, however, tally up some offenses (easy to do in a place with 200 conduct regulations). Little black marks appeared on Seth's record for inattention in ranks, absent from parade, in bed after morning reveille, visiting, bed out of order, late at guard duty, and other minor offenses. But not often.

In contrast, Eastman gained merits in mathematics, engineering, tactics, rhetoric and natural philosophy, drawing, artillery, chemistry and mineralogy, and French. He was good natured and well liked by his chums.

Of all his classes, he excelled in drawing, graduating at the top of his class. His enthusiasm for drawing and art went beyond turning the ups and

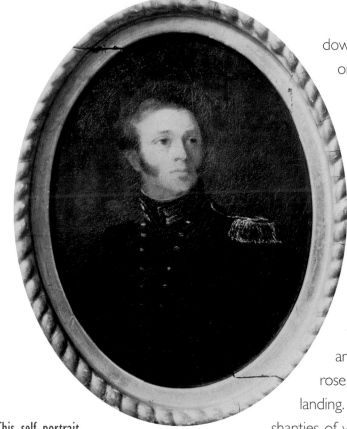

This self portrait, done by the graduating officer, shows how much skill in painting Eastman had acquired as a young student at West Point.

downs of the land into lines, shapes, and measurements on a map. A schoolmate noted, "But for the superior attractions of the military profession, and his fondness for his Army associates, he would probably have embraced the profession of an artist."

Eastman was particularly keen on sketching landscapes. His friend said of him, "In his rambles over the rocks and hillpaths . . . he was never without his pencil and paper."

At Fort Snelling, no one could ignore the landscapes, especially not Eastman. The scenes astounded first-time visitors. One could see for miles, the frost-lined hills and ridges, snow-swamped prairies and woods. Atop Pilot Knob, Dakota burial scaffolds rose. Plunging 100 feet below the fort lay the frozen boat landing. *Tipi* (tepee or tepees) dappled the riverbanks. The shanties of white families (refugees from a failed settlement up north) squatted on the floodplain.

Across from the fort, above the place where the two rivers met, nestled the fur-trading village of St. Peters (now Mendota). Up and down the rivers like stops on a train line were the Dakota villages. Soldiers called them by the names of their chiefs: Wabasha's village, Red Wing's, Medicine Bottle's, Little Crow's, Black Dog's, Little Six's.

Eastman came, he saw, and he sketched. He had time for sketching because fort officers had light duties. As second lieutenant, he might review men at roll calls, oversee a work crew, or check the guards at their posts.

The soldiers Eastman watched over were mostly a disgruntled lot. Many had recently come to America from places like Ireland, Scotland,

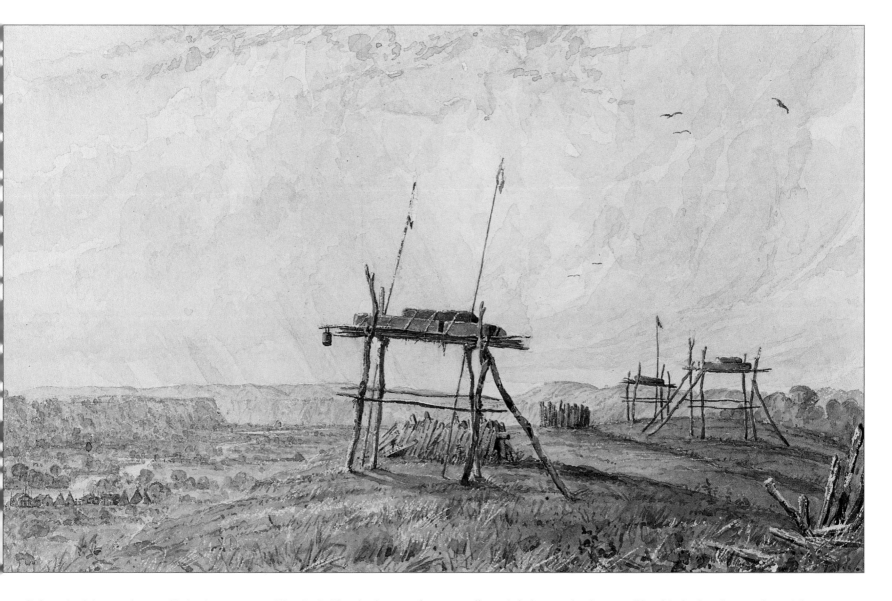

Dakota burial ground, most likely the one atop Pilot Knob. The dead were often sent off on their journey in the next life with food and some favored items, such as their medicine bundles or hunting gear. Pieces of cloth were flown like flags to mark the site or as offerings to the spirits.

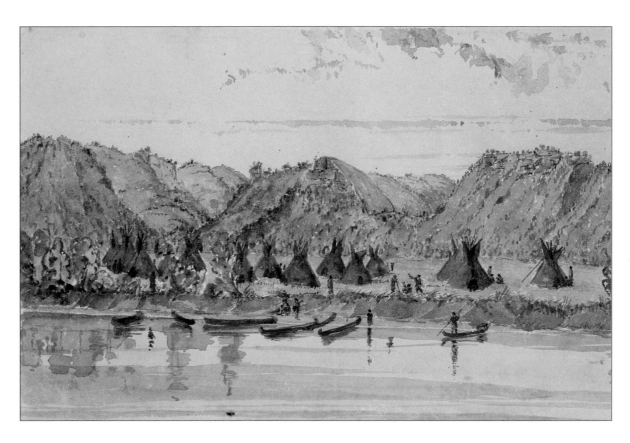

Wabasha's village on the Mississippi

France, Germany, and Holland. They had often signed on to escape something worse: prison, poverty, or a bad marriage. Winter, though, made them wonder: frostbitten feet and hands, ill-tasting food rations, and long, excruciating hours with nothing new to do. Numerous soldiers would splurge the pittance left from their monthly pay (about $7) on smuggled whiskey. They drank too much and deserted whenever they could. Some deserters froze to death in the snow.

In contrast, Eastman and the other officers (as well as the wives and families they brought with them) lived much like aristocrats. Their social calendars included teas, dances, reading in the library, plays put on by the bored enlisted men, card games, checkers and chess, and hunting.

Wolf hunting was a popular sport. The officers would set their dogs on a wolf like hounds in an English fox hunt. Then the men would ride after them until the wolf was caught. Eastman kept his own hunting dog.

A common gathering place in the area, especially for hunters, was the store and warehouse of the American Fur Company in St. Peters. Hunters piled furs and skins high on the wooden counter. Then the pelts were sorted and bundled into one-hundred pound packs. Conversations flowed back and forth in French, Dakota, Ojibwe, and English. Seth could use his schoolroom French.

It may have been at St. Peters that Seth first saw her. Or on a hunting trip that included a stop at one of the lakeside villages. Or even within the fort. Come spring and the opening of the river, a mishmash of people began flowing in and out of the fort's gate: the Dakota and Ojibwe and their mixed-blood relatives (those of white-Indian heritage), French Canadian voyageurs (the fur traders' hard-working laborers), white squatters, missionaries, and the free black servants and the slaves of the officers and Indian agent.

No one now knows where Seth first saw her. But it is clear that as spring winds warmed, wallows of mud replaced snow drifts, and blue pasque flowers poked through prairie grasses, Eastman's thoughts turned to women. Not all women—*Wakaninajinwin,* the daughter of a Dakota chief.

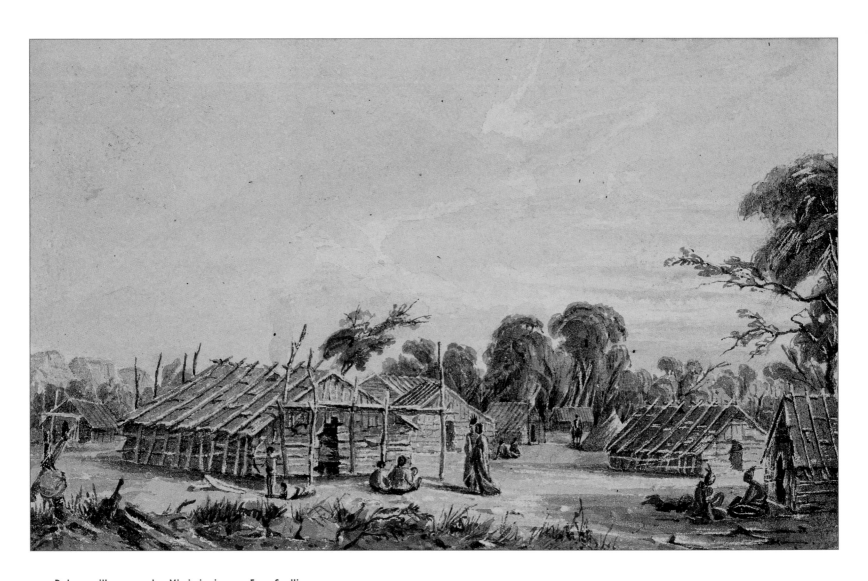

Dakota village on the Mississippi near Fort Snelling

Dakota Kin

1815 to Spring 1830

WAKANINAJINWIN, or Stands Sacred, had grown up along a river, the silty St. Peter's. She was born in Black Dog's Village in about 1815.

Fort Snelling had not yet been built. Nearly seven thousand Dakota lived in seasonal villages along the Mississippi and St. Peter's to the Missouri River. Seven groups made up the Dakota nation. The four known to the soldiers as the eastern Dakota (sometimes called the Santee Sioux) were:

the *Mdewakantonwan*, the Spirit Lake Dwellers;

the *Wahpetonwan*, the Dwellers among the Leaves;

the *Wahpekute*, the People who Shoot among the Leaves;

the *Sisitonwan*, Dwellers of Fish-Scale Places or Fish Ground.

The three western groups who lived on the plains up to the Rocky Mountains were:

the *Ihanktonwan* (Yankton), Those who Dwell at the Ends;

the *Ihanktonwanna* (Yanktonai), Little Dwellers at the Ends;

the *Titonwan*, Dwellers on the Plains.

These seven bands were bound together in an ancient alliance known as the *Oceti Sakowin*—the seven council fires. They shared the same language and similar customs. They called themselves *Dakota*, which means friends or allies. ("Sioux" is a shortened form of an Algonquian Indian word meaning enemy.) The different members of the Oceti Sakowin moved easily among each other's villages.

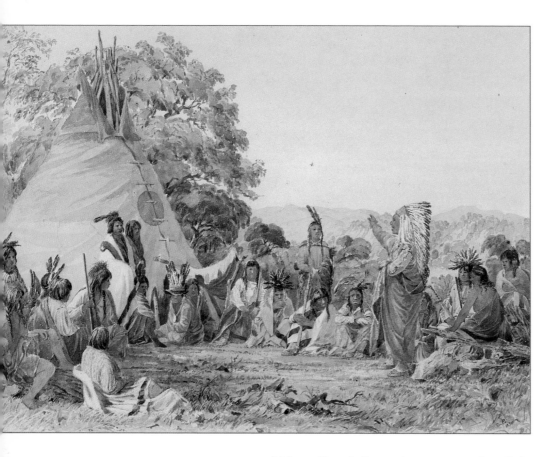

Dakota in council. The Dakota made decisions by consensus. They used speeches and discussions in councils to come to agreement. The man who could speak wisely and well would earn a place as a leader (though chiefs were usually the sons of chiefs). Any man who was kin by marriage or birth could have a place in the council.

When Stands Sacred was young, her father was not yet a chief. He was *Mahpija Wiscasta*, or Cloud Man—the grandson of a Mdewakantonwan chief. Stands Sacred's mother's name was *Canpadutawin*, or Red Cherry Woman. When Cloud Man spoke in council, men listened. When he left for the hunt, men followed. Stands Sacred was the youngest daughter in a family that had earned its place of respect.

By the time Stands Sacred was ten, Fort Snelling had risen on the bluff, and American soldiers had become a part of village life. She had seen a few *wasicun,* or white men, before this. The Dakota had long been used to trading with visitors and other Indian nations. Then French and

British traders had built trading posts in some Dakota villages. Black Dog's was one of them.

The traders became a part of the village. In the fall and on special occasions, the trader would hand out goods to Chief Black Dog: sturdy wool blankets, brass or iron kettles, knives, guns and ammunition, axes, awls, clothes, brooches, bells, bracelets, and earrings. Black Dog would pass the goods out to the families according to the work of their hunters. Cloud Man's family was worthy of many goods. In the spring, Cloud Man and the other village men would provide pelts in trade.

The traders often courted and married women from the villages, according to Dakota customs. The courting man would offer a number of bride presents, such as guns, blankets, kettles, and horses near the family tipi. They showed how much the man valued the daughter and her family and how able he was to provide for the family. Being a Dakota was not essential. What mattered was how willing the man was to become Dakota, become kin. Would he be able to take care of relatives and friends as they would take care of him?

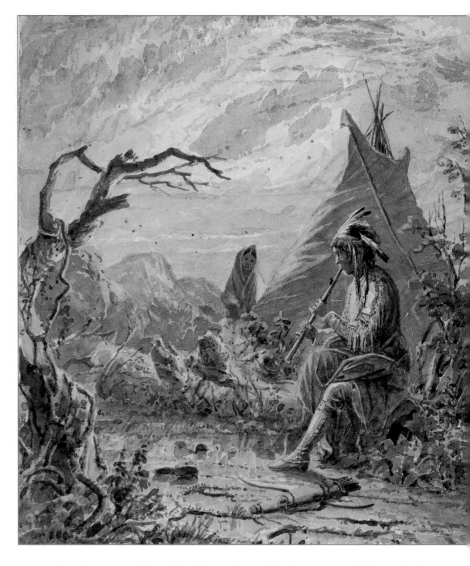

Courting: a young Dakota man plays a flute to attract the attention of a young woman.

Lawrence Taliaferro served as the St. Peters Indian agent from 1819 to 1839. Chief Little Crow called him *No-Sugar-in-His-Mouth.* Other Dakota called him Four Hearts or *Maza Baksa,* which means Iron Cutter, because he gave away iron farm tools.

In courting, it was crucial for the man to woo the young woman and gain her consent. If she disagreed with her father's choice, she could run away, elope with someone else, or in rare cases, kill herself. Knowing this, most parents did not try to push their daughters into marriages the girls did not want.

Officers and soldiers from the fort sometimes married or made alliances with Dakota women. Stands Sacred's eldest sister, *Anpetu Inajinwin,* or The Day Sets, was wooed by the Indian Agent Lawrence Taliaferro. He was considered handsome and an excellent choice. The thirty-three-year-old agent had spent the last seven years giving gifts to the Dakota, listening to their concerns, providing counsel, and trying to bring peace between them and their enemies. He was a man of power. He spoke for the president, the "Great Father" of the United States.

Cloud Man welcomed Taliaferro into his family. He was a good man to have as kin. Since the coming of the fort, changes had stampeded though Black Dog's village like running buffalo. The American Fur Company had taken over many of the fur trading posts. They made a new system. Instead of considering the pelts as gifts or trade, they considered them as money. These traders set up accounts for individual Native hunters, charging a certain number of pelts for each item the hunter took on credit in the fall.

Then, in 1827, the American Fur Company bought another large trading company. Almost every trader now worked for the new company. It jacked up prices 200 to 300 percent or more. In a single season, a tin kettle that had cost about 9 muskrat pelts, or

$2.25, rose to 30 pelts, or $7.25. A $6 musket sold for $18 or 110 pelts.

By the spring hunt, Cloud Man and the other Dakota hunters owed three times what they expected. Game declined and debts rose. Muskets and ammunition became more valuable than bows and arrows and spears. Unless a man had the sharpsighted fire sticks of the wasicun, it was that much harder to feed his family and defend them against the Ojibwe.

Taliaferro urged his father-in-law and the chiefs to turn more to farming, like white settlers. They refused. (Farming was women's work!) But Chiefs Black Dog and Little Crow did ask Taliaferro for plows so more corn could be grown more easily.

That winter, Cloud Man and his hunters had to travel all the way to the Missouri River to find big game. Stands Sacred and her family worried as too many weeks went by. A blizzard caught and buried the hunters. Fortunately, the snows and wind let up just in time. The men found they were near the camp of some western Dakota, who took them in and fed them.

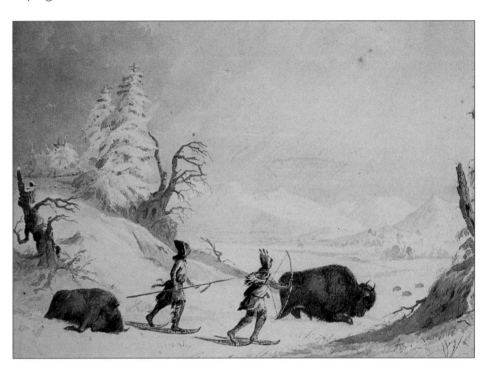

Hunting buffalo in winter. The Dakota wore decorated blankets or hoods in the winter and used two kinds of snowshoes. One was short with curled toe edges for powder, and the other was long with a straight toe for crusted snow.

Upon his return, Cloud Man visited his son-in-law. He was ready to

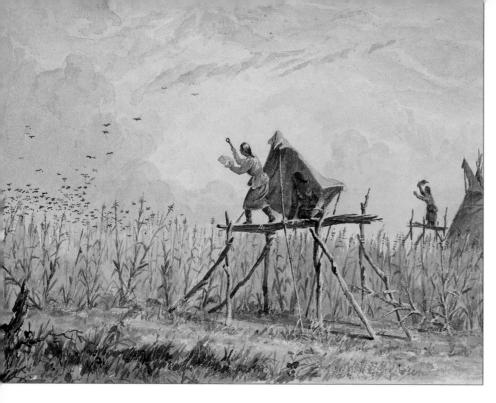

Guarding the cornfields. Children usually helped the women protect the ripening corn from blackbirds, chasing them away by waving, shouting, and making other noises.

experiment. He requested oxen, plows, and seed for a new farming village. Together Cloud Man and Taliaferro chose the spot—nine miles from Fort Snelling on a rise overlooking the agate-sparkling waters of Lake Calhoun (now in Minneapolis). Chief Cloud Man's village became known as *Heyata Otonwe*, or the Village Back from the River. Taliaferro called it Eatonville, after the new secretary of war, John Eaton.

In August 1829, Stands Sacred's family moved to their new village. Day Sets came bringing her toddler, Mary Taliaferro (born in 1828). A number of other families followed. That fall they were harvesting bushels of squash, potatoes, cabbage, pumpkins, and, of course, corn.

Around this time, Stand Sacred's other sister, *Hanyetu Kihnayewin*, or Hushes Still the Night, married Daniel Lamont, a Scottish fur trader. Eventually, they too had a daughter, Jane Lamont.

Now at fifteen, Stands Sacred had reached marrying age. She was a lovely young woman. Lithe and graceful, she had her pick from among warriors, hunters, soldiers, fur traders. As daughter of a chief, she was more prized than ever.

Seth Eastman hoped to be the one who would gain her consent.

Decisions

Spring 1830 to January 1832

STANDS SACRED chose the stately young second lieutenant with the pencil and sketching pad, and they married according to Dakota customs.

Cloud Man's village was little more than an hour's ride to the west of the fort. Playing children and yipping dogs swarmed about Seth each time he rode up the trail.

Eastman studied the ways of his new relatives and mastered much of the Dakota language. He learned how to read a man's eagle feathers to tell his battle history and rank. He kept the gifts his friends and kin gave him: pipes and adornments, quilled bags and clothing.

At the fort, Eastman's life changed little. He and the other officers (sometimes the officers brought their families from the fort and sometimes they didn't) took a wagon or horses to the lakes, the Falls of St. Anthony, and to Little Falls (also called *Mini Haha*). Meanwhile, the soldiers farmed, cut hay for the horses, and chopped wood for winter. They all waited for news from Prairie du Chien. A conference had been called to work out an agreement among the Dakota, Sac, and Fox. An earlier peace treaty had not held.

News came. The army promised to keep the peace if the three nations would each sell a strip of land on the edge of their hunting grounds to the federal government. These strips would work like moats to keep the nations separate.

The Mdewakantonwan would receive $2000 a year from the sale.

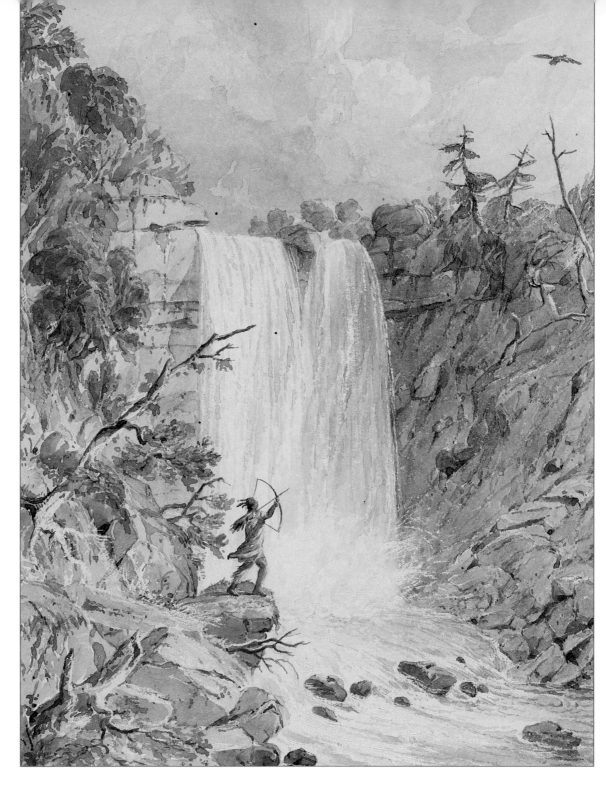

28 The Little Falls, or Laughing Waters *[Mini Haha]*, three miles below the Falls of St. Anthony

The money would help ease their trading debts. The Mdewakantonwan could then use the money to purchase the weapons and ammunition they needed. Taliaferro planned to put some of the money into Eatonville for more tools and storage. He wanted to make a successful experiment of what he called "my little Colony of Sioux Agriculturalists."

As treaty news arrived from the south, one hundred and seventy Ojibwe warriors arrived from the north. They headed to the Indian Council House at St. Peters Agency to confer about the new trading practices, their lands, the government, white settlers, and the Dakota.

Taliaferro was edgy. Eastman and other officers were put on alert. Anything could happen with the Ojibwe and Dakota so close together.

The Ojibwe chiefs and warriors gathered in the log council house. Peace pipes, feathers, and medals decorated the walls. The United States flag hung in its center. The men of the agency and post sat at a table while the Indian men reclined upon the ground around it. Complaints were heard and discussed. Finally, peace was promised.

The Ojibwe and Dakota celebrated with feasts and sports. The Ojibwe traded maple sugar and birchbark canoes for buffalo robes and corn. Dakota men "found strange beauty in the oval faces" of the Ojibwe women, and the Ojibwe men found the slender gracefulness of the Dakota women striking.

Even so, no one trusted the goodwill to last.

On August 14, 1830, at one o'clock in the morning, Eastman woke to shouts of alarm in the fort: FIRE! FIRE! FIRE! The guard had seen flames against the night sky to the west at the Council House. The troops arrived as soon as they could, but there was little to be done. Scott Campbell, the mixed-blood interpreter, and his family, who lived in one section of the house, had just managed to escape. The army fought the flames and kept them from spreading. They saved the roof of Major

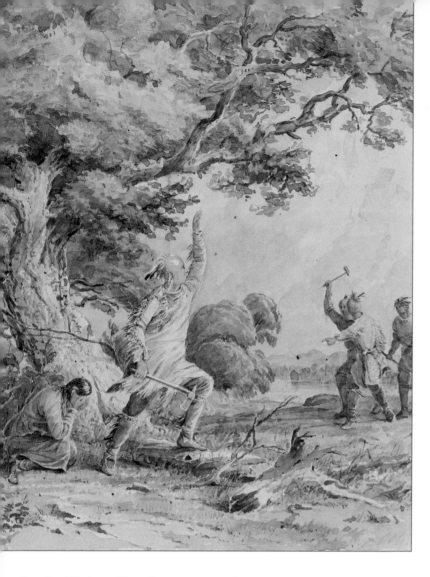

Sounding Wind, an Ojibwe, has fallen in love with a Dakota woman, whom he saves from being killed by other Ojibwe during a period of intertribal war. Dakota and Ojibwe men and women often met on the neutral grounds around the fort.

Taliaferro's stone home and the blacksmith's log workshop.

An Indian who had been drinking had set the fire. Just as whiskey ravaged the army troops, it also took a high toll among the Dakota and Ojibwe.

Despite the fire, the peace held.

The Ojbiwe returned to their northern villages, and a party of "Missouri River Indians" (western Dakota) moved in. They camped about the fort for the winter.

February brought a new rash of fires, this time in the officers' quarters. Eastman and the others became watchful lest they become toasted in their beds. Then on February 24, the agency house was again on fire, this time from the inside and out. A new Council House would have to be built.

After that, the fires stopped. But Seth had already had enough. He wanted to go back east. The longer he remained on the frontier, the less likely it was that he would be promoted. Or develop further as an artist. Or apply his drawing skills as a topographical engineer. (He particularly wanted the army to use his skill in making maps and surveys.)

Seth began to send out applications for army assignments with better prospects.

Signs of spring flew in. Late on Sunday, March 27, 1831, Major Taliaferro noted in his diary that the weather was "more pleasant—Wild geese seen

this day—gentlemen generally out and Walking—The Ladies also."

Around this time of wild geese, Stands Sacred was in the sugar-making camp at Lake Harriet. She gave birth to a child. The infant, with light skin and dark eyes and hair, was called *Winona*. This is an honorary name meaning "first daughter." All Dakota children at this time were given a name that told their place in the family. Winona appeared on agency records as Nancy Eastman.

Seth Eastman was now a father, forever linked to the Cloud Man family. He was Dakota kin.

Not long after his daughter's birth, Seth let his temper flare among his new relatives. It was a near deadly mistake.

On June 29, 1831, a number of Ojibwe leaders were meeting at Eatonville to talk peace. Taliaferro wrote in his diary: "Lieut Eastman without the least provocation caught one of the Sioux young men . . . by the hair of the head & pulled him severely for some time & this too in the presence of both nations—a great disgrace & affront offered to the Indian—one of the Indians was about to strike Lt E to the ground but he was prevented from committing murder by his Father & some others."

The Indians filed a complaint. Yet when Eastman's commander asked them about it, they denied it. It was evident they did not want to get Eastman into trouble; they wanted to repair relations.

Eastman later explained to Taliaferro that the youth, called The Gourd, had shot and killed his pointer dog. Gourd admitted this was true. "I did not see Lieut Eastman until afterwards and if I had not been drunk, the thing would not have happened—I had no bad intentions against anyone."

To pay for the dead dog, Gourd offered Eastman his horse. He said that he hoped Eastman would not hold the dead dog against him since they were "relation."

Taliaferro noted: "If Officers of the Army identify themselves with Indians

& become *as it were allied* to their families—insults of the kind . . . may be expected sooner or later." (Taliaferro's alliance with Stand Sacred's sister was now considered over. In 1828, the year of his daughter Mary's birth, Taliaferro had traveled to Pennsylvania for an extended time. He met and married a white woman, Elizabeth Dillon, and she returned with him to the St. Peters Agency.)

Eastman *had* allied himself with the Dakota. But he was allied first to the army. And the army answered his requests. He was reassigned to topographical service.

The transfer was what he had hoped for, but he would have to leave behind Stands Sacred—and ten-month-old Winona.

Still, he accepted.

On January 19, 1832, Second Lieutenant Seth Eastman said good-bye to Company I, his fellow officers, and "many good friends among the Indians." One of his Dakota grandchildren would later describe what he had heard of this parting: "Seth was very tender toward his child . . . on his last visit to his child, he pressed it to heart while tears ran down his noble young face."

Eastman set up an account for his Winona, or Nancy, at the American Fur Company store. He left her uncle Major Taliaferro as trustee. The agent would best understand the movements of army money and how to work with the traders. Winona would be raised by her mother, in her grandfather's village, with her cousin Mary Taliaferro. According to Dakota customs, Stands Sacred, like Seth, would be free to marry again.

As Eastman left the fort, he had nothing yet worthy of the exhibit halls of the East Coast. But something more important had happened to him. He had entered the kinship circle of the Dakota. He now knew the woodland "Sioux" better than any other painter in America.

And, though he didn't know it, he would return.

Map of an Artist

January 19, 1832 to January 1840

THE "IRON HORSE" had just begun galloping across the United States. Tracks for steam-powered railroads were being laid across the seaboard states. At twenty miles per hour, the locomotive looked like it could pull the whole nation into the future.

Eastman's orders sent him to Louisiana, a place of sugarcane and cotton plantations. Here he surveyed the land, making way for the railroads. Within six months, he was transferred to New London, Connecticut, to serve with the Topographical Engineers stationed there—probably for another railroad survey.

Then, on Christmas Eve, 1832, Eastman's drawing teacher at West Point, Thomas Gimbrede, died unexpectedly. A call went out for a replacement. On January 9, Seth Eastman was commanded to return to West Point to become the assistant teacher of drawing.

Seth preferred active duty, but this was a plum position. He'd be closer to his family. He'd be more in touch with top officials, who could promote him. And there'd be only 50 miles between him and New York City's art exhibitions. He could study under the new drawing professor and exhibit in New York.

It may seem odd for a military school to be teaching drawing and painting, but in the time before easy photography, the army depended upon men who could sketch accurately. Generals needed detailed drawings when they made battle plans. A commander had to know how steep a ridge was

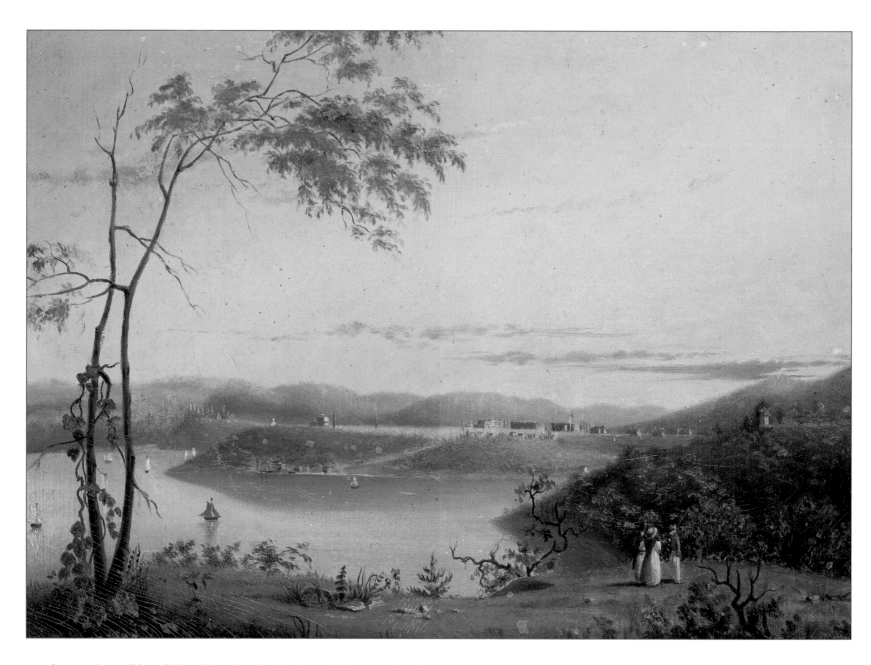

A romantic rendition of West Point, New York, by Second Lieutenant Seth Eastman

if he wanted his men to charge it or where a river was for bringing in supplies. Army draftsmen also measured and sketched sites for construction and engineering. At times, they even recorded history by painting major meetings and treaty signings.

Eastman taught classes by himself for most of the first year. He probably focused on what he knew best—topography, the charting of the details of the land. His course encompassed: geographical signs; portraying rocks, hills, rivers, lakes, and marshes; forming letters; using brushes; applying broken and blended tints; and shading.

Eastman had a definite idea about how to make maps understandable: every topographical draftsman should use the same symbols, signs, shadings, and measurements. So Eastman invented a system. He established tables of symbols that could be used in all maps. A series of parallel lines equalled a river. Horizontal lines were a pond. He soon became so absorbed he started working on his own textbook: *Treatise on Topographical Drawing.*

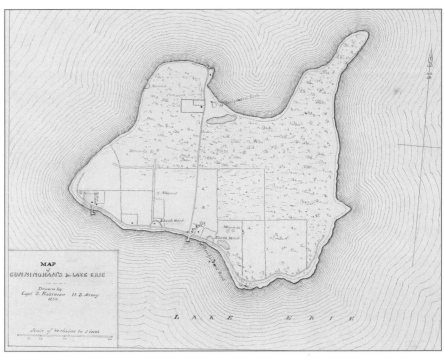

Eastman defined topographical work as sketching a place as if you could see it from the sky. He explained how to draw objects with height, depth, and width on a flat piece of paper. Details were all important. "The best rule that can be given is to imitate nature," he advised. "And here a knowledge of landscape drawing is an advantage."

Topographical map of
Cunningham Island, Lake Erie

Part of the art of landscape drawing, for Eastman, was in picturing nature in a way that could show distances. He figured out a formula to give drawings this perspective. He began work on twelve illustrations for his book.

In mid November 1833, the new professor of drawing finally arrived—Charles Robert Leslie. He was an American artist who had a studio in London. A famous professional, Leslie knew painters around the world. Working with him meant breathing in the oil-pungent air of famous galleries, and Eastman wanted more of this air. He was determined to become skilled enough to create his own oil paintings and see them exhibited.

But within six months, Charles Robert Leslie sailed back to his old life in England. Leslie complained that student schedules totally absorbed time from his art.

Robert W. Weir was the next teacher hired. Though not as famous as Leslie, Weir was respected for his landscapes. Since Eastman had a "fondness for natural scenery," this new professor proved a good choice to be Seth's private tutor in painting.

Weir began teaching at West Point in August 1834.

By this time, his assistant, Seth Eastman, had found another passion besides painting: sixteen-year-old Mary Henderson. Her father, Dr. Thomas Henderson, had become West Point's assistant surgeon in February 1834. The fact that Mary was young and wore skirts would have been enough to get her noticed at the all-male academy. But she was also vivacious, charming, well-read, chatty. And Mary was bulldog-tenacious when she wanted something.

At some point, she decided she wanted Seth.

Eastman had a close friend, Francis Henney Smith, the assistant professor in geography, history, and ethics. He also had an eye for a Henderson daughter. His choice, though, was Mary's sister Sarah. On June 9, 1835, Sarah and Francis were wed (one of Seth's sons would be named after Frank). It

may have been a double ceremony, with Seth and Mary also at the altar. All that is definitely known is that within the year, seventeen-year-old Mary Henderson married the twenty-seven-year-old Seth Eastman.

A friend of Eastman describes this time as "peculiarly happy." Seth had married a woman who believed in his talents, and he was moving up in his career. In 1836, he was promoted to first lieutenant. His first son, Robert Langdon, was born, and Seth was "developing still further his great talent as an artist."

West Point was the perfect spot for an aspiring landscape painter. Hilly country roads led to scenic villages. Ivy clung to brick walls. Fleets of sloops sailed the Hudson River.

Just upriver in the Catskill Mountains, a few landscape artists were painting dramatic scenes of wild nature. They painted with oils in the outdoors instead of in a studio so they could be more accurate in their detail. These painters, such as Thomas Cole and Asher Durand, grew popular in the American art world. They were dubbed the "Hudson River School." Weir and Eastman, who lived near, no doubt saw their work and were influenced by them.

Into his sketchbook, Eastman poured numerous renderings of rocks, tree trunks, sloops, and Hudson River views. They were so accurate it is clear he drew them outdoors. He developed some into watercolor pieces and then into full-scale oil paintings.

In 1836, he finally broke into the New York art world. His painting *View of the Highlands, from West Point* was accepted for display at the National Academy of Design in New York City. The *New York Mirror* wrote that it was happy to welcome this pupil of the accomplished master Robert Weir to "stand among our landscape painters."

Eastman began submitting landscapes annually. *Sunset Parade at West Point* was shown in 1837.

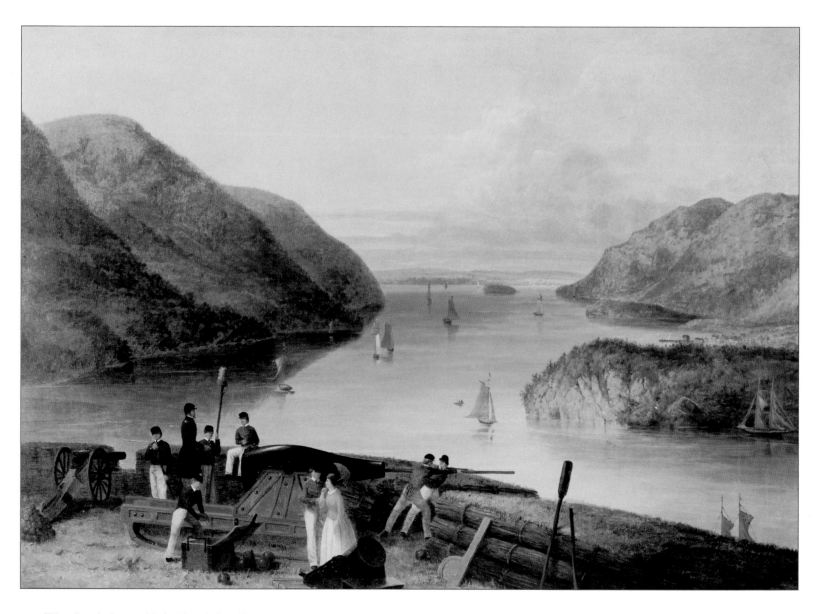

This oil painting entitled *West Point, New York* demonstrates Eastman's growing competency as a landscape painter.

That year, his *Treatise on Topography* was published by a New York publisher. The U.S. Army made it the required textbook for all topography classes at West Point.

Success followed upon success. In 1838, eight of his landscapes were accepted for the Design Academy's exhibition. At this show, Eastman exhibited for the first time works based on the sketches made at Fort Snelling. Two paintings were of the fort itself and another was entitled *Landscape: Moonlight View of the Mississippi.*

Based on his strong showing, the Academy awarded him membership. This was one of its highest forms of praise. Eastman went on to complete eighteen to twenty large-scale oils. His topography training enhanced his works. It made him attentive to the land's shapes and details. An impressed reviewer noted that every detail was so "correct" that plants could be identified by their leaves and bark. Rocks could be determined by their geology.

His reputation grew. In 1839, Jefferson College in Mississippi invited him to become the professor of topographical drawing and painting. (He said no.) That same year, the U.S. Army promoted him to captain.

The Eastmans needed the money that this promotion brought. Their family now included Thomas Henderson Eastman, and another child was expected. Promotions, however, came at a cost. Captain Seth Eastman was being transferred to a war zone. In fact, he was being sent to one of the roughest, most disliked duties in all of America—fighting the Seminoles in Florida Territory.

From Landscapes to Indians

January 1840 to September 1841

MARY AND THE CHILDREN stayed in New England while Captain Eastman returned to his regiment, the First Infantry. It was posted at Sarasota, Florida.

Though the territory was named *Florida*, or *Feast of the Flowers*, soldiers feared duty there. Men died in droves from malaria, dysentery, and other tropical illnesses. And who could be proud of chasing groups of women and children through swamps? The army's job was to round up the Seminoles and drive them onto a reservation in Indian Territory (now Oklahoma), west of the Mississippi River.

The Seminoles were a mixed group of Indians who had come together as a people in Florida over the 1700s and early 1800s. Many were stragglers from the Creek nations to the west. Some were survivors from the Indian nations that had been killed off by Spanish explorers and conquistadores. African and Indian slaves who had escaped from Georgia had also become Seminoles.

Eastman and his unit were sent to Fort Fanning. This was a temporary camp on the Suwanee River. Officers and soldiers lived in tents or cane huts. Enormous cockroaches scuttled around the floors, fleas infested the bedding, and mosquitoes swarmed their skin. Panthers screamed and alligators yawned from jungles of cypress and Spanish moss. Then there were eerie sounds the soldiers could not even identify.

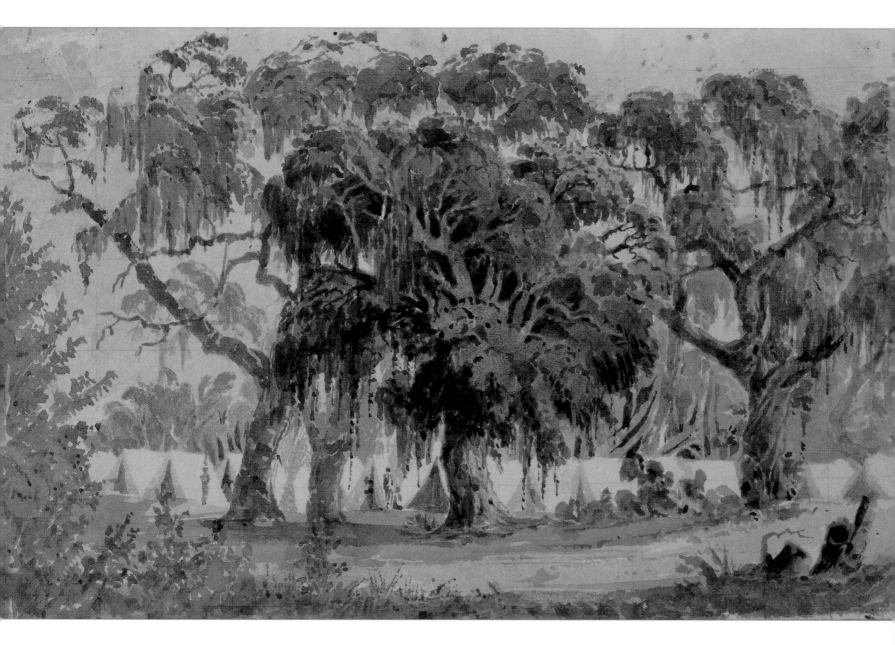

Encampment of the First Infantry in Sarasota, Florida, 1841

One officer wrote home: "I am here, uncomfortable, [drinking] wretched water, eaten up by insects in an unhealthy climate, suffering from heat, indifferent food, scarcely any fresh meat, and this to support my family. I say no more." Another wrote: "Rain, rain, rain, will it never cease its eternal patter!"

War duty in Florida was both dull and dangerous. And Captain Eastman didn't like it any better than anyone else.

Most of the time, when they searched, the troops found no one. Only deserted villages or places where the Seminoles had just been. Still, reports of deadly attacks kept coming.

Despite the dangers, many officers thought the war was unnecessary and that the treatment of the Seminoles was unjust and cruel. Major Hitchcock, a high ranking officer in this effort, wrote in his diary: "The government is in the wrong, and this is the chief cause of the persevering opposition of the Indians, who have nobly defended their country against our attempt to enforce a fraudulent treaty."

No one knows how Eastman felt about his duty. He was not the kind of man to write long letters describing his feelings. He sketched instead. Many of his drawings were of landscapes, of course. Yet he also displayed an interest in the Seminoles—not as enemies, but as people. They became the focus of some of his sketches and watercolor paintings. An artist friend later wrote that Eastman's artwork had "done much to make us [the public] acquainted with the Seminoles of Florida." Unfortunately, most of Eastman's Seminole paintings have been lost.

Eastman was shedding one dream and growing another. He no longer seemed to be striving simply to follow Professor Weir or the landscape artists of the Hudson River School. He was mapping his own path on a different frontier—that of an Indian painter.

This deserted village had belonged to Seminole Indian Sam Jones's band, who had fled at the first sign of the approaching army.

Mary Eastman describes this new mission in a letter to a congressman: "After Capt. Eastman's graduation at West Point, and while on duty there, he devoted the time at his command to the study of painting, looking forward to making a collection of pictures, that would some future day form an Indian gallery."

Eastman had little time to pursue his artistic mission in Florida. Like many of his men, he grew ill. One soldier claimed that the main duty of the healthy soldiers was not looking for Seminoles but taking care of the sick and burying the dead.

Fort Snelling from two miles downstream

In June 1841, while the remainder of captured Seminoles were being driven west, Eastman was transferred to Norfolk, Virginia, to recover his health. His family joined him. While recuperating, he sketched landscapes and neighborhood scenes. But this was just busy work while he waited for another chance to implement his plan.

That summer he was transferred—back to Fort Snelling. Mary wrote: "When his scene of duty was changed to the Western frontier, he commenced to put in operation his long cherished plan. He was not satisfied with drawing the scenery of prairie and river,—he studied closely the peculiar history and customs of the interesting peoples who were yielding their territory to us. This study was not a mere occupation; it became a passion with him."

Return to a World Familiar and Strange

September 1841 to May 1846

RED AND GOLD LEAVES hung over the banks as the steamboat pulled up to the landing. Captain Seth Eastman and his family (now including little Virginia) came down the gangplank. The fort struck Mary as impressive as "an old German castle" and the scenery "rich in beauty." But the high pitched yells and shouts of the Indians filled her with alarm.

Eastman's old friends among the Dakota crowded around, wanting to meet his new wife. They shook hands with Mary and placed their hands on the little light-haired boys. They called Seth *Chaska,* meaning "eldest son."

Four times during the next seven years, as the senior officer present, Captain Eastman would be in command at Fort Snelling. Though much was familiar to Eastman, many changes had occurred.

Fort Snelling was no longer as cut off from the world as it had been. Steamboats traveled up and down the Mississippi more often, and numerous roads cut through the prairies. Tourists from the East Coast and Europe came to visit the fort, the prairies, St. Anthony Falls, and the beautiful Little Falls.

The squatters who had built their shanties near the fort had been chased off by the troops. They had settled downriver at the landing where a French Canadian whiskey dealer named "Pig's Eye" Parrant lived. Two months after the Eastmans arrived, Father Lucien Galtier, a Catholic priest, dedicated a log cabin there as the Chapel of the Apostle St. Paul. Soon everyone was calling the new settlement St. Paul's.

Up river at the village of St. Peters, Henry Hastings Sibley had taken charge of the American Fur Company's headquarters. Sibley was a hospitable host and a hard-nosed business man. He put strict accounting measures into practice. All accounts were payable in dollars, not pelts. He approved only of providing powder, lead, and shot in the fall—no food staples or other things for survival. He cut some older hunters off completely, thinking they wouldn't bring in enough pelts. This outraged Dakota and Ojibwe alike.

Captain Eastman did not get involved. He left Indian affairs to others, unless laws or treaty agreements were broken (or were about to be). He and Henry Sibley became good friends, hunting together and trading favors. Sibley's brother-in-law, Franklin Steele, was the store sutler at the fort, so Eastman came to know him too.

At the fort, Mary delighted in the role of hostess, inviting in local missionaries, visiting artists, tourists, and reporters. She also kept her door open for Dakota visitors. Mary wrote: "Some Indians visited us every day, and we frequently saw them at their villages. . . . They looked at my husband as their friend, and talked with him freely on all subjects, whether of religion, customs, or grievances."

No doubt they talked little of Seth's former wife or his eldest daughter. But Mary had to hear of them, either from Seth or others, since the mixed-blood children of the soldiers were "open secrets" at Fort Snelling.

Stands Sacred had married again, and Cloud Man's farming village had moved to avoid Ojibwe raids. His band eventually settled about six miles up the St. Peter's River from the fort, at Oak Grove (now Bloomington). Stands Sacred and Winona attended the mission church, and Winona studied at the school. Stands Sacred was baptized as Lucy, and Winona as Mary Nancy Eastman.

Sit-down dinners were not the usual fare for the Eastmans' Dakota visitors. They got whatever could be found in the kitchen—"cold beef, cold

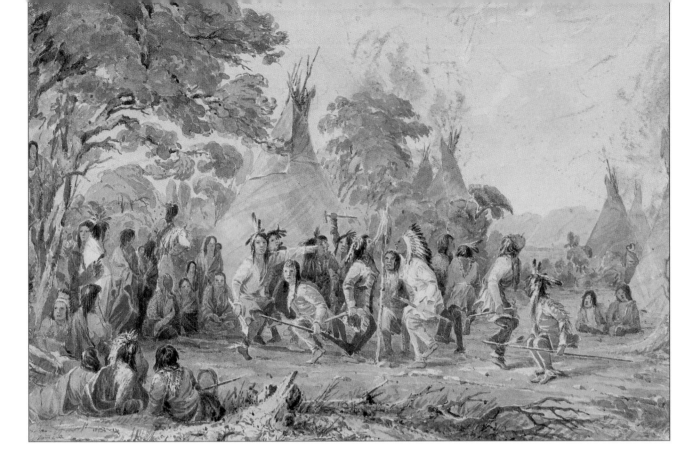

Dog Dance. The Dakota loved and highly respected their dogs. The Dog Dance was sometimes performed to inspire the men, invoke help in battle, or display courage. A dog was religiously sacrificed and the heart and liver hung on a pole. Warriors would crouch and act like dogs, yipping, snapping, biting, and swallowing the meat to show how brave they were.

buckwheat cakes; nothing went amiss," Mary wrote. Favorite meals were of pork and apples, with a mixture of molasses and water as a drink. "Then they had to smoke a little and nod before the fire—and by and by I heard all about the Great Spirit, and Hookah the Giant, and the powers of the Sacred Medicine."

Mary plied them with questions and collected their stories. Checkered Cloud, a medicine woman, passed on many legends and romantic stories. Mary even tried to learn how to sing in Dakota. But her teacher, Little Hill, a famous singer, soon gave up on ever getting her to sing like a Dakota woman.

She couldn't get the throaty sounds right.

While Mary questioned and wrote, Seth sketched and painted. He fixed up a studio in the fort and hired Dakota to sit for him. Mary wrote: "They thought it supernatural (Wahkun) [*wakan,* holy or sacred] to be represented on canvas. Some were prejudiced against sitting, others esteemed it a great compliment to be asked, but all expected to be paid for it."

When Seth took his equipment for daguerreotypes (an early form of photography) out at a celebration, the Dakota villagers watched carefully. They were astonished to see themselves appear on the plate. "Eastman is all wahkun!" Mary quoted them as saying.

In the ten years Eastman had been away from Fort Snelling, Dakota lives had changed permanently. *No-Sugar-in-His-Mouth,* Indian Agent Major Taliaferro, was gone. Gone, too, were big game near the fort and eastward. Beaver and grizzlies had disappeared from the woods, and the last buffalo east of the Mississippi had been shot in the mid 1830s. Without enough pelts or meat, Ojibwe and Dakota villagers needed money to buy food supplies and goods. In 1837, Ojibwe and Dakota chiefs had signed treaties with the United States government. In exchange for yearly payments of food, clothing, farm tools, other goods, and cash, they gave up gameless lands east of the Mississippi. It seemed a reasonable deal.

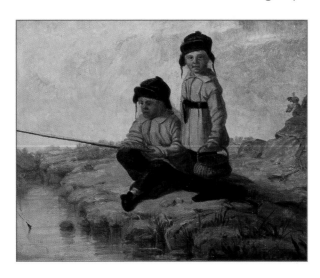

Eastman's small sons fishing at Fort Snelling

All had not gone as promised, however. Sibley and his traders claimed large sums of the Dakota money for unpaid debts run up by individual hunters. Remaining payments came late, and so did the goods. Worse, they were often shoddy or ridiculous. What use were castanets and handkerchiefs?

Tensions between the Dakota and the traders, army, and Indian agent rose, and tempers nearly exploded. But then the new Indian agent managed to acquire the payments and decent goods. Things looked better.

Then new problems arose. Dakota children began to ask for bread made from flour instead of boiled corn. Government pork and beef started tasting better to some Dakota than hard-won venison or buffalo. Receiving payments was easier than hunting or farming, but living totally by dollars and cents was new. It was especially difficult if one didn't know the wasicun math. Feastmaking didn't fit budgets. Money was often thrown away on whiskey.

The Sisitonwan and Wahpetonwan had not sold lands, so they did not receive yearly payments. They grew more desperate each winter. The winter of 1842–1843 was one of the fiercest ever. By the first of November, the ground was covered with high drifts. Winds blew bitter. Hunting was difficult, and fishing near impossible because the snow blew into the ice holes as soon as they were cut.

The Sisitonwan traveled two hundred miles down the St. Peter's River to reside near Fort Snelling. Blankets and hunting supplies were passed out at the fort. The officers saved the remains from the tables, and once a day the Dakota women and children were allowed to come and receive "these crumbs."

Mary wrote: "Frequently we have heard of whole families perishing during the severe cold weather. The father absent on the winter's hunt, the mother could not leave her children to apply to the fort for assistance, even had she the strength to reach there."

Mary described when a woman with a newborn infant came for help. "The wretched babe was shrivelled and already looking old from hunger. She warmed it by the fire, attempting to still its feeble cries. 'Do you nurse your baby well, Wenona?' I asked; 'it looks so thin and small.' 'How can I?' was the reply, 'when I have not eaten since it was born?' "

The fort commander at the time, Major Dearborn, sent sixty bushels of corn and several barrels of pork upriver to help those who remained on the prairie. But there was not enough. Some Dakota starved to death and were found frozen in their lodges. Others "lived upon a syrup made of hickory chips and the boiled bark of the bittersweet."

That spring, fighting was fierce between the Sisitonwan and the Ojibwe bands over hunting areas. In August, a treaty session was held at the fort. The Ojibwe and Dakota were warned that if they harmed each other, the government would hold back their payments.

Another change had occurred while Seth had been away. Missionaries had created an alphabet for the Dakota language. Along came a dictionary, school primers, hymnals, and a Dakota Bible. Some Dakota children and their mixed-blood cousins started to learn to read and write in Dakota. They studied the Christian religion. English and mathematics were taught too. During the years 1844–46, missionary schools had no fewer than 236 students a year. Studying marks in books was a big shift from learning the ways of the animals and ancestors through observation and memory. A number of Dakota leaders saw such learning as a magical experience. Others feared the "talking paper."

The Eastmans could see that the Dakota people were changing rapidly to deal with the changing world around them. Many traditional ways seemed to be falling away. Mary wrote that the Dakota are "as the setting sun, or as the autumn leaves trampled upon by powerful riders. . . . The hunting grounds . . . will soon become the haunts of densely peopled, civilized [Mary meant white] settlements."

Using his skills with pencil and paint, Seth was documenting the traditional ways of the Dakota before they disappeared.

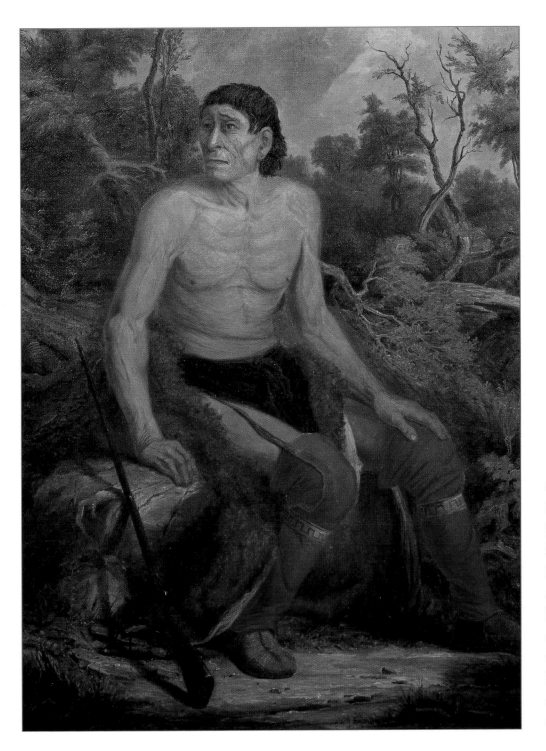

Ohokeape was a great Mdewakantonwan leader and hunter who had been imprisoned by the British and came home a broken man. He did odd jobs around the fort, and he was hired in the winter months to use his dog travois to pick up and deliver the mail. Eastman often painted him. He seemed symbolic of some of the harsher changes that had come to the Dakota.

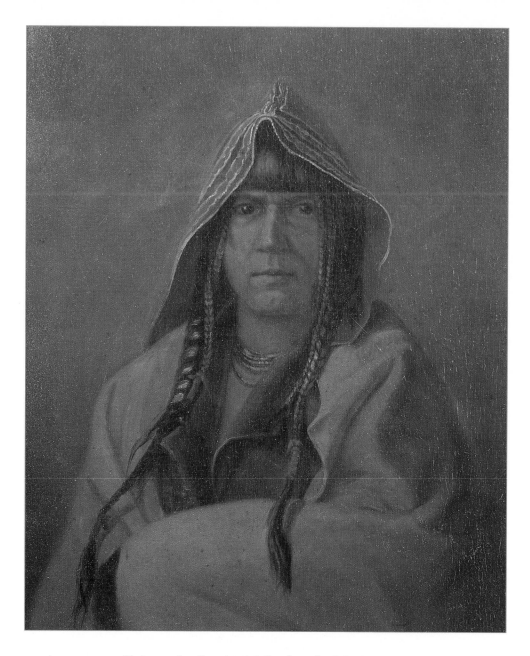

In contrast to Ohokeape, Eta Keazah, or Sullen Face, lived farther from the fort and whites. His strong, determined, intelligent gaze characterized the Dakota who had not given up their traditional ways. Eastman probably painted Sullen Face when the man was imprisoned at Fort Snelling. Sullen Face had mistakenly killed a white man, thinking he was someone else, someone who had killed some of his people.

Dakota Days

September 1841 to September 1848

SETH EASTMAN filled his sketchbook with drawings of the Dakota doing everything from sitting a certain way to chasing a buffalo on horseback. He inquired about things he didn't understand and added piece after piece to his collection of Dakota articles. These he used to make sure every detail he drew or painted was precise and accurate. He even used a tame buffalo!

Eastman's artwork shows how well he came to know the Dakota ways, rooted in the land and dependent on its seasons.

The Dakota year was measured by the full moons.

Cackling crows returning to their roosts were the firecrackers that announced the Dakota new year—SPRING—*Wetu*.

The spring fur hunt occurred in April, in *Magaokada-wi,* The Moon When Geese Lay Eggs. This was when the animals were easier to hunt and their fur was still thick and valuable. So the men traveled to the swampy haunts of muskrats and otter (nabbing beaver, mink, and marten too if they were especially lucky). Since muskrat mounds rise above the

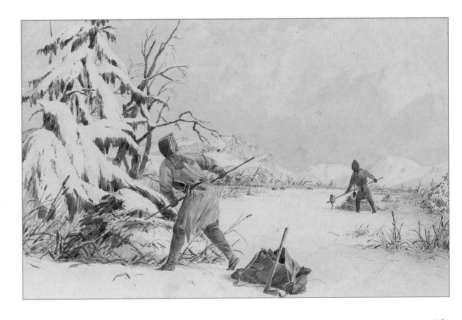

Hunters spearing muskrats

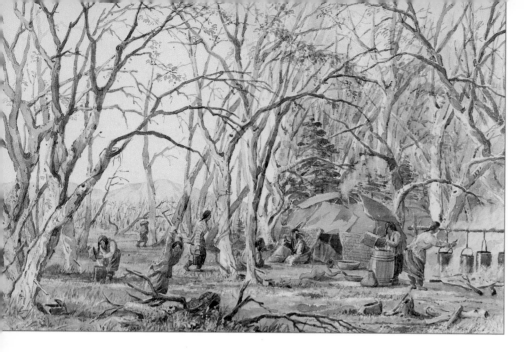

Indian sugar camp. The Dakota made little domes of cattail mat or elm bark for their sugaring lodges, although sometimes they used tipi.

water, they absorb heat and thaw before the ice cracks. The hunters would thrust in their spears or hatchet open the den.

Back in the woods, the Dakota women, children, and a few men (generally youth and elders) were all hard at work maple sugaring. A bark sugaring house had been erected (either of cattail mats or birch or elm bark, whichever was nearest). The women cut down a few trees and hollowed them out to collect the maple sap. They gathered firewood and hung brass and iron kettles over the fire areas.

Small taps of hollowed sticks or carved wood were hammered into the sugaring trees. Once the sap began to drip, everyone moved at a faster pace. Women and girls carried sap and poured it into the heated kettles. Older women or little boys took charge of keeping the fire going and stirring the kettles. The sweetest part of this job was the taste testing of the syrup (done as often as possible when the boys were in charge!).

The women poured some of the readied sap into molds made of wood or the bills of ducks and geese. As it cooled, the sap hardened into sugarcakes and candies. The best-tasting candy and sugar was made from the box-elder trees. The Dakota also gathered bitter sap from the ash and birch trees for medicines.

When the sap stopped flowing, everyone packed up. They harnessed the dogs and horses to drag two poles for the travois. Slung between the

poles were straps or a net for carrying loads. The women piled on the sugar and supplies, and moved on to their summer homes. They carried the heavy burdens on their backs, using a head strap made of buffalo skin to help balance the weight.

The summer villages consisted mostly of elm-bark lodges, supported by posts. These were built by the women (except for the roofs, which were raised by the men) and owned by them. The lodges were often quite large, housing a number of generations and related families. Each family generally had its own corner and fireplace, with a hole for the smoke. In front of the lodges, scaffolds served as porches for

shade, hanging racks for drying hides and vegetables, and bunks for sleeping on hot, humid nights.

The Planting Moon, *Wozupi-wi*, began sometime in May. With the earth warmed, the women took digging sticks to the ground. They mounded the dirt and planted corn, and sometimes potatoes, squash, and pumpkins. This was a lean time. Winter supplies usually had been used up, and food was hard to find. The villagers often had to depend on catching fish, ducks, and turtles.

This was a time, while the men were still off hunting, for the boys to shine. They would strike off with their bow and arrows, spears, lures, and nets to bring home food. Ohiyesa, one of Eastman's Dakota grandsons, described

Indians traveling. The two-poled carrier the Dakota attached to horses and dogs to drag loads was called by the French a "travois." The eastern Dakota had some horses, which they often received through trade or gifts from their relatives, the western Dakota. The western Dakota were able to capture wild horses on the plains. Mostly, however, the eastern Dakota depended on their trusty dogs.

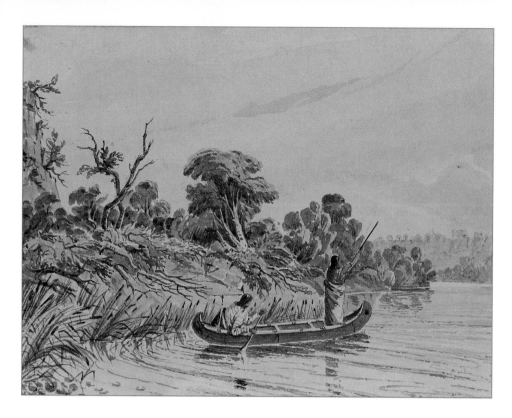

his early hunting adventures: "Our game consisted mainly of small birds, rabbits, squirrels, and grouse. . . . It was not merely a hunt, for we combined with it the study of animal life. We also kept strict accounting of our game, and thus learned who were the best shots among the boys."

Girls often learned to hunt and trap as well, but they never had as much time to devote to it. They had to learn the skills of the women.

Indian spearing fish below Fort Snelling. Boys learned from an early age how to fish. Girls learned how to steer and paddle strongly and silently, making it easier to catch the fish unaware.

Women worked very hard and almost all the time. Gathering wood and hauling water in skin bags took up much of their days. The wood had to be dry, and it often took a great deal of walking to find fuel, since all the other women were also looking. Buffalo chips and other dried droppings would be used when wood couldn't be found.

They wove baskets and sweetgrass mats for the lodges. They fashioned bark vessels and storage containers. Children were their special care.

When it came time for a girl's first menstrual period, it was Dakota custom for her mother to take her to a small tipi, or elm-bark hut, away from everyone. The young woman would stay there for four days or so, while her mother taught her the most difficult steps in sewing and quilling. Then she had to make things on her own—perhaps a pair of moccasins, some mittens, or a hunting bag—and embroider them with colored porcupine quills, ribbons,

bells, and glass beads. This was an important testing time. It was thought that the girl must quill for four days. If she did this, she would be good with the awl. If she did not, she would never be industrious.

Most girls were given their own special awls. They used the awls to make holes in the tanned hides before sewing the skins with a thread of deer sinew. On the awl's handle, each young woman would make marks to show the number of hide lodges, bags, and garments she had made. Like a man's eagle feathers, which marked feats in battle, this quilling count showed a woman's work of honor.

Dakota youth were schooled with lessons daily. Parents, aunts and uncles, or elders would tell them stories, and in a day or so, the children had to recite the stories back. Had the children listened and remembered? Had they learned what was important? The children were taught to be alert, to observe and learn from the animals and plants, and to respect and act like their elders.

Menstrual lodge

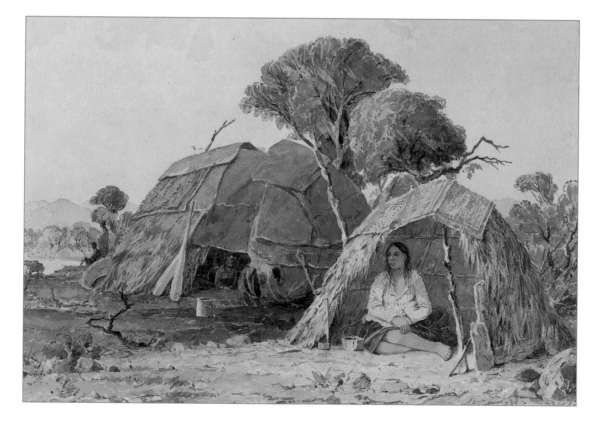

57

In most Dakota villages, there were lodge societies, like clubs, for learning special skills, such as quilling, weaving, hunting, or telling tales. There was the Soldiers' Lodge for the *akicita,* or chief's assistants (men who led the hunts and also acted like the village police). There was the Medicine Lodge for leaders (men and women) of religious ceremonies and healings.

To be allowed (or invited) to join the Medicine Lodge was a special honor. These men and women were the village spiritual advisers and healers. They cured people by making them right with the spirits. These leaders depended upon visions, dreams, fasting, listening, and prayer to guide their treatments. Cures could include smoking, sweating, sucking bad spirits out, and applying medicines. These *wakan* men and women required training to understand and practice as healers.

The Dakota also had healers who were more like doctors than priests. They used herbal medicines and performed minor surgeries. They were often midwives too.

The herbal doctors collected their medicines from the woods and the

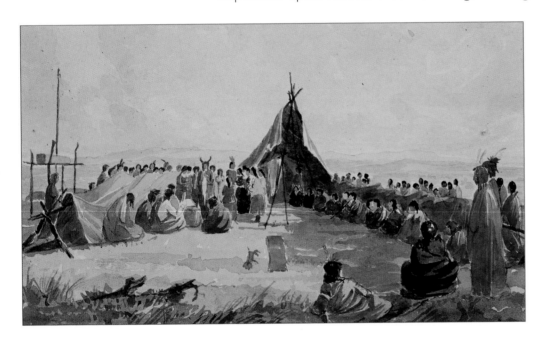

The Medicine Dance of the Dakota. This sacred curing ceremony of the woodland Dakota was not meant to be captured in pictures. This painting shows the setting up of the oval dancing ground. The spectators would stand outside of the hide barricade and watch as the members of the Medicine Lodge danced and drew out sickening spirits from those who needed healing.

prairies. In *Wajustecasa-wi*, the Moon When the Strawberries Are Red (June), most of the food and herb collecting began. By this time, the men had returned. Strawberries ripened first, then blueberries, huckleberries, and hazelnuts.

The Dakota would split into small groups daily or weekly, going where they felt they would find the most food. The men would go out hunting for part of a day or for several days. Many traveled by foot or by canoe, fishing in the early morning and at dusk. A woman often paddled while her husband or brother waited, spear in hand, ready to pounce.

As the summer drew on, out came the Moon When the Chokecherries Are Ripe, or *Canpasapa-wi* (July). The women picked chokecherries and pin cherries. They pounded them to loosen the stones from the fruit and sweetened their pemmican with the fruit pulp. Pemmican was a mixture of fruit, dried meat, and fat—the perfect energy food for a long hunt.

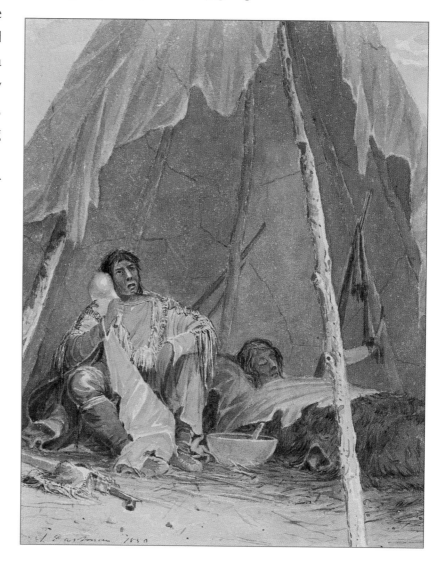

Medicine man ministering to a patient

59

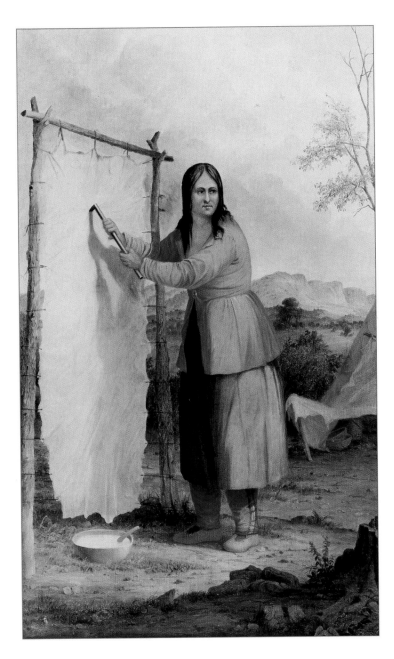

Indian woman dressing a deer skin

Come midsummer, hunters chased game in the woods and buffalo on the prairies. Women cut and dried the meat, and tanned the hides. Every skin had to be stretched and scraped and beaten (or chewed) and rubbed with animal brains to make it soft.

The women also hoed and tended the fields. Blackbirds and crows were their mortal enemies. The women would sit atop scaffolds, where they could watch both the fields and the children. They would shout and wave their arms at the birds, sending the children on foot to chase the blackbirds from the fields.

All was not work. Boys swam and played games in the woods, preparing to be hunters and warriors. Ohiyesa explained: "Our games were feats with the bow and arrow, foot and pony races, wrestling, swimming. . . .We had sham fights with mud balls and willow wand; we played lacrosse, made war upon bees."

Throughout their play, the children were followed by their pets: young foxes, bears, wolves, raccoons, fawns, buffalo calves, birds of all kinds, and of course, their faithful and work-ready dogs.

The next month of the summer, *Wasuton-wi*, the Harvest Moon, when the corn is collected (August), was a time of work and feasting.

The corn was gathered, dried, or parched (partially cooked), and then stored in birch containers. All was buried for winter, and the spot carefully hidden. Wild turnips and other roots were dug up; seeds were collected.

Most years, Wasuton-wi brought visiting and midsummer celebrations. Village bands and family clans packed up their tipi and met for reunions. "The invitations," explained Ohiyesa, "were bundles of tobacco."

There was juggling and storytelling, gambling and sports matches. Heralds would go through the encampments announcing events: feasts, dancing, games, shooting contests, canoe races, wrestling matches, foot and pony races, swimming, and lacrosse games on the prairies, as well as the names of winners and losers.

Lacrosse was played a bit like soccer, with goals at either end of a field. But the ball was small and wooden, or a hide-covered stone. Instead of using one's feet, the players wielded a stick with a small net at the end (like a long-handled minnow net) to catch, carry, and throw the ball past the goals.

Ohiyesa described a big lacrosse game between the Wahpetonwans and the Kaposias (Mdewakantonwans from the villages of Wahpeton and Kaposia) on the Wahpetonwans' home turf:

> The ground selected for the great final game was on a strip of land be-
> tween a lake and a river. It was about three quarters of a mile long and a quar-
> ter of a mile in width. . . . The most powerful men were stationed at the half-way
> ground, while the fast runners were assigned to the back. It was an impressive
> spectacle—a fine collection of agile forms, almost stripped of garments and paint-
> ed in wild imitation of the rainbow and sunset sky. . . . Some had undertaken to
> depict the Milky Way across their tawny bodies, and one or two made a bold
> attempt to reproduce lightning. Others contented themselves with painting the fig-
> ure of some fleet animal or swift bird on their muscular chests.
> At the middle of the ground were stationed four immense men, magnificently

formed. A fifth approached this group, paused a moment and then . . . instantly the little black ball went up between the two middle rushers, in the midst of yells, cheers, and war-whoops. Both men endeavored to catch it in the air; but alas! each interfered with the other; then the guards on each side rushed upon them. For a time, a hundred lacrosse sticks vied with each other, and the wriggling human flesh and paint were all one could see through the cloud of dust.

The teams rested in a kind of half time, and then the game went on:

Suddenly, a warrior shot out of the throng like the ball itself! Then some of the players shouted "Look out for Antelope! Look out for Antelope!" But it was too late. . . . Such speed, he had cleared almost all the opponents' guards—there were but two more. . . .The two men, with a determined look, approached their foe like two panthers prepared to spring; yet he neither slackened his speed nor deviated from his course. A crash—a mighty shout!—the two Kaposias collided, and the swift Antelope [a Wahpeton] won the laurels!

It might seem like nothing could outdo these games, but the feasts were also incredible.

There was often competition to throw the best and finest feasts. Each part of the meal, as well as any activity, included ritual acts. These were done to show respect for and thanks to the Great Mystery (Great Spirit) and all the spirits of the earth, water, and sky. Mary Eastman described a feast: "The pipe is lit and smoked by all present; but it is first offered to the Great Spirit."

Since no one carried a china cabinet from camp to camp, guests usually brought their own utensils and bowls. "When all are served, the word is given to commence eating; and those that cannot eat all that is given them must make a present to the host." These folks of small appetite also had to hire someone to eat their leftovers. To waste a morsel would offend the Great Mystery.

In Dakota custom, one did not strive to gain wealth to keep it, but to

give it away. Missionary Samuel Pond wrote: "There was much also given to the poor, such as widows and orphans, especially of food, for none were ever suffered to starve if there were provisions in the camp. . . . Collections were taken for those who were very destitute."

Gambling and games of chance were popular Dakota pastimes, and they kept goods moving too, from person to person, and family to family. In these games, fate decided who would get the winnings. The women shook plum stones marked with spots, which worked much like dice. They'd bet belongings on which spots would come up when they dropped the stones. The men played a game called "the shot and mitten," betting on which mitten would hold the ball after the mitten shuffling stopped. Men and women would also bet on the ball games and sports matches. But a person couldn't bet what he or she didn't have in hand, so this type of gambling didn't create debt.

Besides gambling and feasting, romance added excitement to midsummer days. Courting could happen any time of year. But under starry moonlit skies with warm gentle breezes flowing, who could resist? It was especially common during the large get-togethers and dances, though men and women danced separately.

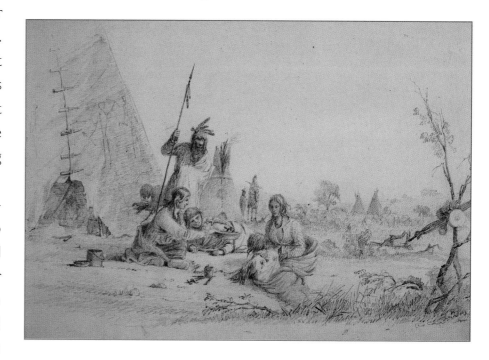

Dakota women played a gambling game with plum stones marked with spots. They would bet belongings on which spots would come up when they dropped the stones.

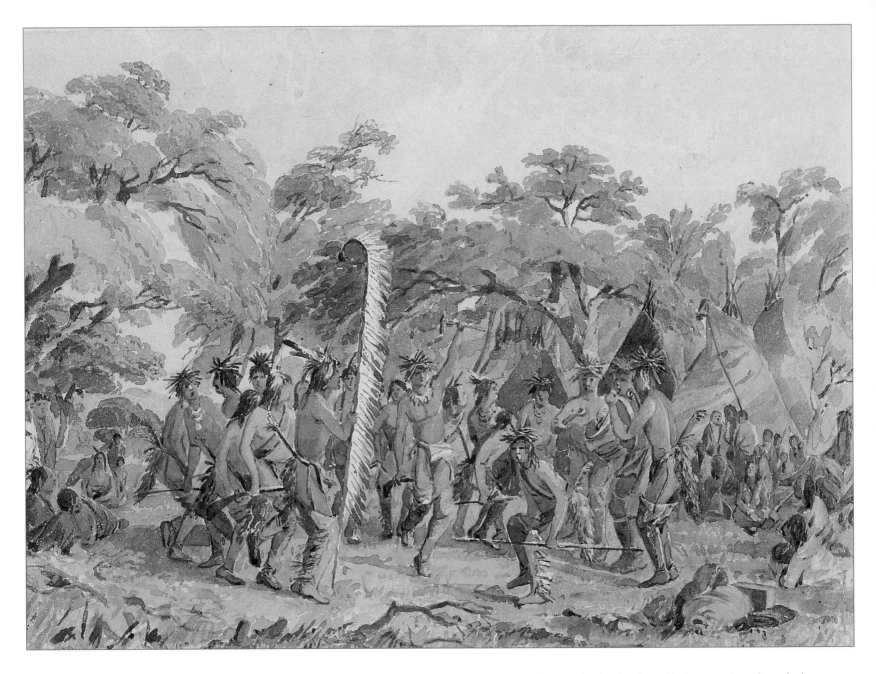

This picture depicts a special Dakota ceremony called the Beggar's Dance. Many of the respected leaders in the band would dance to beg the onlookers to open their hearts and give to the poor. By giving much away, one showed the largeness of one's spirit, wealth, intelligence, and generosity, as well as one's hunting and food-gathering prowess.

Ohiyesa wrote, "As soon as the youth has returned from the war-path or the chase, he puts on his porcupine-quill embroidered moccasins and leggings, and folds his best robe about him. He brushes his long, glossy hair with a brush made from the tail of the porcupine, perfumes it with scented grass or leaves, then arranges it in two plaits with an otter skin or some other ornament. If he is a warrior, he adds another feather or two."

Many a young man would serenade softly or play the flute to catch a young woman's attention. The tunes played were usually unique to each family, passed down from father to son.

If a young woman was not interested, she would simply keep walking. Or she would make sure her chaperone came by. But, if she gave the young man some encouragement, he would lay bride presents before her father's lodge or tipi. He might wait many a day and night outside the home watching, hoping the gifts would be taken in.

If both families agreed, the bride would dress as lavishly as the family could afford: with costly blankets adorned by colorful silk ribbons that formed patterns and figures; embroidered leather and cloth; silver earrings and chest disks or brooches; beaded necklaces.

Mary Eastman described a Dakota bride: "Her moccasins were worked with porcupine, and fitted closely her small feet; the leggings were ornamented with ribbons of all colors; her cloth shawl, shaped like a mantilla, was worked with rows of bright ribbons, and the sewing did honor to her own skill in needle-work. Her breast was covered with brooches, and a quantity of beads hung round her neck. Heavy ear-rings are in her ears—and on her head feathers. She has a bright spot of vermillion on each cheek."

The bride's family would escort her to within a hundred yards of the tipi or lodge the couple would share. Then a respected elder would give a short speech, announcing the names of the bride and groom, and making

Dakota written music on birch bark

some comments. Once this was finished, the father would call for the young man to fetch her. Either the groom would come from the lodge, or he'd send a messenger. The bride then had to climb onto the back of this man to be carried into their home. The young men watching would shoot their guns and arrows skyward, over the couple's heads. The whole village would burst into serenades of loud yells and cheers for the newlyweds.

With so much activity, midsummer passed quickly. It was soon *Psinhnaketu-wi,* the Moon When Rice Is Laid Up to Dry, or September. Groups of fifteen to twenty families gathered at each wild ricing lake. More canoes were made (both birchbark and dugout) so that nearly every other member of a family had a canoe. Feasts and offerings were given in honor of *Unktehe,* the "Water Chief", the spirit of the waters and underworld, so that there might not be any drowning accidents.

"On the appointed day," Ohiyesa wrote: "all the canoes were carried to the shore and placed upon the water with prayer and propitiatory offerings. Each family took possession of the allotted field, and tied all the grain in bundles of convenient size, allowing it to stand a few days. Then they again entered the lake . . . the foremost one gently drew the heads of each bundle

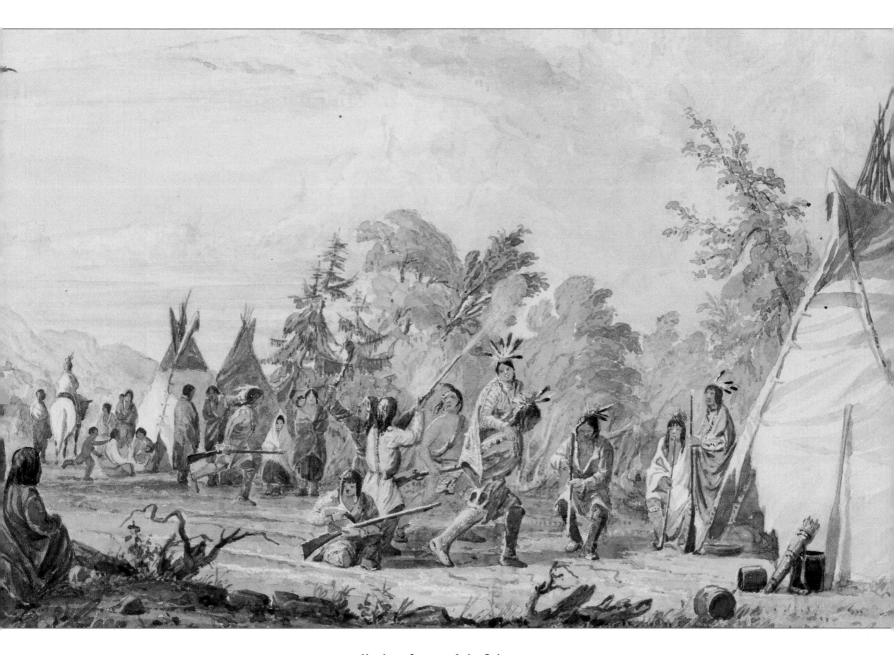

Marriage Custom of the Dakota

toward him and gave it a few strokes with a light rod. This caused the rice to fall into the bottom of the craft." The women would also fill canoes with the edible bulbs of water lilies and arrowroot.

Once collected, the rice was laid in the sun on buffalo robes and mats, or spread atop a scaffolding above a fire. After drying, the rice was heated and poured hot into a hole two feet wide and deep. "A young man, having washed his feet and put on a new pair of moccasins, treads upon it until it is all hulled. The women then pour it upon a robe and begin to shake it so that the chaff will be separated by the wind . . . there were prizes offered to the young men who could hull quickest and best. There were sometimes from twenty to fifty youths dancing with their feet in these holes. Pretty moccasins were brought by shy maidens to the youths of their choice, asking them to hull rice."

Most of the hulled rice was buried in hidden storage places lined with sweet grass. The rest was parched and packed to bring back to the summer lodges.

Soon it was *Canwapekasna-wi,* The Moon When the Wind Shakes the Leaves Off the Trees (also *Wi-wazupi,* the Drying Rice Moon), or October. Once again, everyone was on the move, this time on the fall hunt for deer, bear, elk, and buffalo. Each village would set off for hunting areas within range of their summer lodges. The men went ahead on these hunts, carrying their supplies, spears, knives, guns, bows and arrows, and traps. The women and children, with help from the older men, would pack everything else that was needed and follow. Those who couldn't travel would stay behind at the summer village.

At arrival, the women cleared the ground and set up the tipi. They packed grasses around the lower edges for insulation. Once snow came, it would be packed against the tipi for even more insulation.

The hunting parties followed careful rules, enforced by the *akicita,* or members of the Soldiers' Lodge. If a hunter downed an animal, it was not his

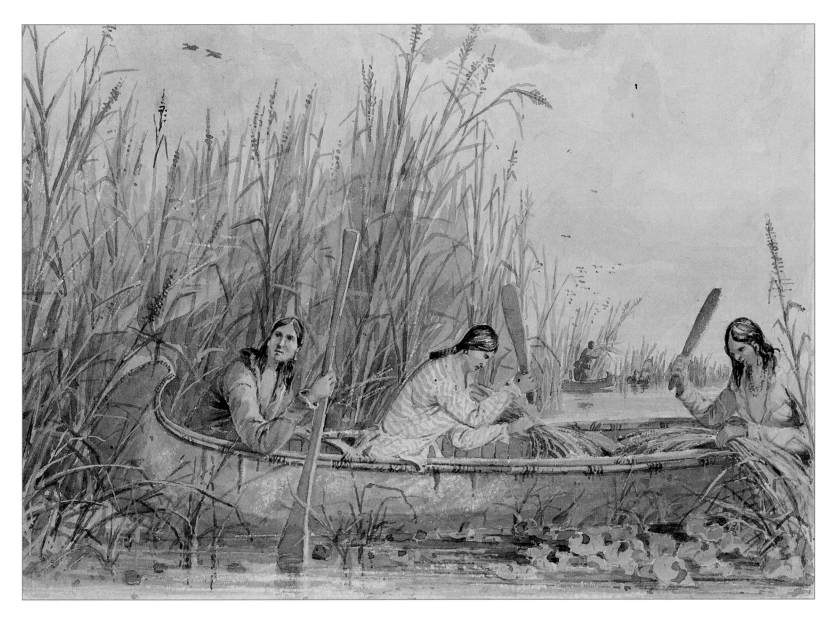

Ohiyesa noted that among wild-ricers "the happiest of all, perhaps, were the young maidens, who were all day long in their canoes, in twos or threes, and when tired of gathering the wild cereal, would sit in the boats doing their needlework. . . . The maidens learned to imitate the calls of the different water-fowls as a sort of signal to the members of a group . . . so that while the population of a village was lost to sight in a thick field of wild rice, a meeting could be arranged without calling any one by his or her own name. It was a great convenience for those young men who sought opportunity to meet certain maidens, for there were many canoe paths through the rice."

alone. Samuel Pond recalled, "Their rules required that any one who was hunting with others should, on killing a deer, give notice to any who were within hearing, by a certain shout. . . . If no one came, he cut up the deer and carried it home; if two or three came, each had a right to a certain portion of the flesh. . . . The one who killed the deer always kept the skin and wrapped up his part of the flesh in it."

The hunting parties would keep moving, taking as many animals as they could in a certain spot. They continued this through November—*Takiyuha-wi*, the Moon When Deer Rut, and December—*Tahecapsun-wi*, the Moon When Deer Shed Their Horns (or Antlers).

Each time a hunter returned with game, the boys of the camp would announce the man's triumph. They'd call out to the village his name and the animal he killed. The boys made it a contest to see who could spy each man first and yell the loudest.

As winter turned its coldest, in January or *Wi-tehi*, the Hard Moon, hunting camps turned toward home. Animals now were too difficult to catch and too lean to make the catch worth the effort. If needed, the Dakota would use dogsleds to bring home the meat and tipi through high drifts.

They came home to camp near their summer lodges and caches of stored food. Here they settled in to wait out the rest of the winter. The men ice fished and caught small game, smoked pipes, and rested. Arrows were made, and bows and tools repaired. Women took time to embroider by the firelight. Elders schooled and entertained the children. There was so much to learn and remember about the animals and plants, hunting and religion, morals, and the people's history.

If the hunt had not been successful and the weather was blizzardy and cold, life was very hard. Ohiyesa recalled, "We were once three days without much fire and all of this time it stormed violently." Another time "we had

nothing to eat for several days. I well remember the six small birds which constituted the breakfast for six families one morning; and then we had no dinner or supper to follow! What a relief that was to me—although I had only a small wing of a small bird for my share!"

However, if there had been game aplenty and the weather was mild, the next month, *Wicata-wi,* or The Raccoon Moon, was a time of great midwinter fun. Whole villages went visiting. The Dakota played rough and tumble games of lacrosse on the ice. Women played as well as men, but they played separately. Children skated with elm bark attached to their moccasins and slid down hills on buffalo-rib sleds. They pitched snowballs and spun wooden tops.

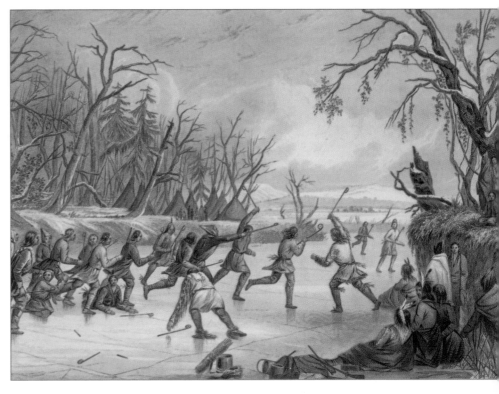

Since warm weather made traveling easier, enemies could attack at any time. The Dakota had to be ever on the alert. War parties usually struck near dawn. For that reason, many Dakota taught their children to wake up and go to sleep with the birds. At the sounding of an alert, women would immediately begin digging a hole to hide the children. If the pit was big enough, the women would lie on top, and the men would fight above them.

Ball play of the Dakota on the St. Peter's [Minnesota] River

Boys were raised to be brave and seek honor in battle. The Dakota

had many religious dances to ask for bravery and show gratitude for success. When someone was killed, friends and relatives were bound by honor to avenge the death. So small parties sometimes went in search of the enemy, most often Ojibwe. The groups were often made up of a few veteran warriors and young men eager to make a name for themselves with battle honors.

To be successful, warriors had to move swiftly to the enemy's camp, strike early and hard, then escape. They had to carry as little as possible. If a man killed or touched a fallen enemy, the man won the right to wear an eagle feather. Eagle feathers were signs of rank, bravery, and courage, much like military uniforms and badges.

When Dakota died in battle (or from other causes), families and friends did not accept it lightly. Howls and songs of grieving would fill the air. Mourners would put on their shabbiest garments and give away their better clothing. Many would slice their upper arms or lower legs. They would crop their hair short, cut their blankets in two, and blacken their faces. These actions marked the depth of their sadness and called down pity from the spirit world.

The mourners would wrap the body and place it on a scaffold or suspend it from a tree. This gave mourners a chance to visit the dead before their last farewell, and it kept the body from scavenging animals. The earth was frozen for much of the year, so it was a good way to protect the body until it could be buried. In caring for the dead, the Dakota followed religious customs. Mary Eastman observed that "every act of their life is influenced by their religion."

The last month of the Dakota year occurred in March. It was *Istawicazayan-wi*, the Moon of Sore Eyes, when the sun flashed so brightly off the snow you could be blinded. The weather was usually warmer, but animals were leaner and so were the Dakota. In that time, the people looked forward to the new year and the running of the sap.

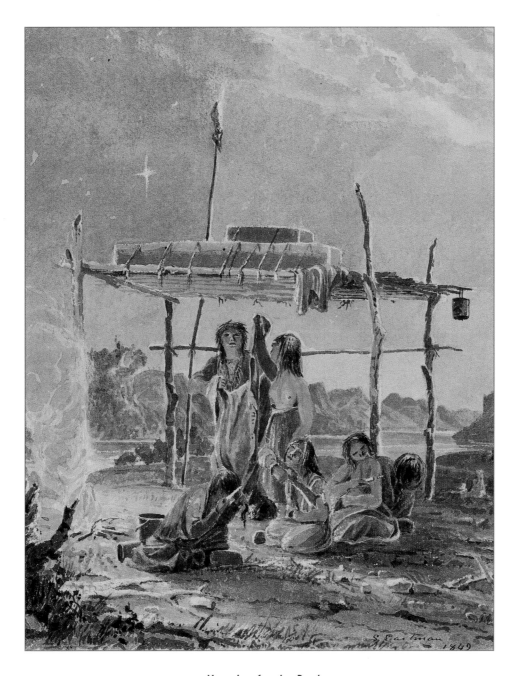

Mourning for the Dead

Commander, Artist, and Book Illustrator

May 1846 to September 1848

SETH EASTMAN'S REPUTATION as a painter was growing.

In June 1846, landscape painter and journalist Charles Lanman traveled by steamboat up the Mississippi. He wanted to encounter the wild landscapes so boasted about by companies sponsoring fashionable steamboat trips. Like other artists visiting Fort Snelling, Lanman made it a point to meet Captain Eastman and tour his small studio.

Lanman was astounded at what he saw. He wrote that this "soldier-artist of the frontier" had dedicated his leisure time "to the study of Indian character, and the portraying upon canvas of their manners and customs, and more important fragments of their history. The Sioux tribes have attracted most of his attention, although he has not neglected the Chippeways [Ojibwe]. . . . The collection now numbers about four hundred pieces, comprising every variety of scenes, from the grand Medicine Dance to the singular and affecting Indian Grave."

It was an impressive accomplishment by anyone's standards. The question remained, what should Eastman do with all his paintings? They belonged together. Yet who would ever pay for such a large collection? Eastman had five children to educate, and that would be difficult on a captain's pay—little more than $100 per month. There might be a chance, he told Lanman, that a "distinguished college" would accept the gallery in exchange for his children's educations.

Eastman considered selecting the landscape scenes of the Mississippi and publishing them in book form as a pictorial tour of the river. Mary also had plans for some of her husband's art. She was working on a book called *Dahcotah; or, Life and Legends of the Sioux.* What could more perfectly illustrate her stories than her husband's artwork?

After a recruiting trip to St. Louis and Galena, Illinois, Seth contacted Wiley and Putnam, the publishers of his topographical textbook. He sent them "one hundred water coloured sketches of the Mississippi—for publication. They are views from the Falls to the mouth of the Ohio." Mary sent her book proposal as well.

On the Mississippi, 140 miles above Prairie du Chien

Wiley and Putnam said no to the Mississippi book and yes to Mary's book with Seth's illustrations. More options arose. A fellow artist, Henry Lewis, asked if Seth wanted to work with him on a Mississippi panorama.

Panoramas were the newest thing in entertainment, a forerunner of motion pictures. Artists would paint pictures of an exotic trip on hundreds of yards of canvas, which was then mounted on rollers and unrolled before appreciative audiences. Lewis's Mississippi River panorama would measure 1,325 yards long and twelve feet high.

Seth was undecided. He wrote to Lanman: "I dislike to leave my Indian pictures." And so he didn't. Instead, Eastman sent one of his paintings to St. Louis with Lewis. The newspaper the *Missouri Republican* wrote of the soldier artist and his picture: "He has been enabled to transfer to canvas a more animated picture of real Indian life than any we have ever seen." This painting, *Indian Burial*, went on to the American Art Union in New York, and the Union bought it. Other paintings followed Lewis to St. Louis, and then east to the American Art Union. Lewis bought some to copy for use in his panoramas. Other works traveled to Cincinnati to be exhibited by the Western Art Union.

The *Missouri Republican* rated Eastman "out of sight the best painter of Indian life the country has produced, quite unlike the vast mass of Indian pictures it has been our bad luck to see."

By March 1847, the soldier-artist of the frontier became commander of Fort Snelling. His brief bits of official correspondence abound with routine activities: enlistments and discharges, muster rolls and desertions.

In January 1848, scarlet fever rampaged through the fort. Mary and the children (now including little Frank) caught it. The disease, with its fever and vomiting, laid out Mary. But it hit little Virginia, about eight years old, the hardest. And Mary could not care for her. Nor could she easily afford to hire help

or get help from other families at the fort who were also fighting the illness.

Perhaps Seth suggested it. It probably was not a welcome idea, since Mary would have a hard time admitting that her husband had a wife before her. But despite how much Mary may have hated to do so, it appears she turned for help to the seventeen-year-old Mary Nancy Eastman. Fort surgeon Dr. George Turner wrote to a friend: "Mrs. Eastman sent for Mary [Nancy?] to come quick to take charge of the sick child and seemed willing to resign herself totally to an enemy's care and Mary [Nancy] has not neglected her charge. It was a strange scene and one which I hope will teach Mrs. E. a salutary lesson."

It is difficult to say whether it did or not. Mary Eastman commented in her book about how grateful she was for the Sioux women who sat by her child's bedside. She did not mention or describe Nancy.

Virginia recovered, as did Mary and the other children. If Nancy did sit by Virginia's bedside, she no doubt became reacquainted with her father. Nancy's family recalled that she saw her father in 1848, the first time since she was a baby. Nancy was now known among the Dakota as *Wakantankawin*, Great Spirit Woman. She was considered a woman of outstanding beauty in body and spirit. She was "generous and kind and a friend to everybody, young and old."

Great Spirit Woman by this time was married to a young man, Many Lightnings. She had a daughter of her own, Mary. Nancy would have four more children.

With the crisis of the illness past, Seth continued to paint and look for opportunities to make a name for himself artistically and sell his collection as a whole. St. Louis papers regularly referred to him as the nation's premier Indian painter. However, to actually achieve this, he'd have to be closer to the Capitol in Washington and to East Coast art markets.

He could not spend much energy pursuing a new assignment, however. Dakota and Ojibwe conflicts were on the rise. He had Ojibwe men in the guardhouse and Dakota murder suspects on the loose. Yet Thomas Harvey, superintendent of Indian Affairs west of the Mississippi, was not overly concerned. "Captain Eastman has his eye upon them."

Adding to the tension, an Ojibwe man killed two whites, and the settlers hanged him. His relatives prepared for revenge. Eastman needed to stop them, but he couldn't act immediately—he was called south to face another emergency.

The Winnebago, originally from Wisconsin, had been moved to a reservation in Iowa Territory. But the government wanted them farther west of the Mississippi. Since the Ojibwe needed supplies and relief from debt, they agreed to sell a strip of land northwest of the Mississippi for a Winnebago reservation. This would place the Winnebago right between the Sisitonwan and the Ojibwe, struggling over the same game-scarce hunting areas.

When the Winnebago reached Wabasha's Prairie (presently Winona, Minnesota), they refused to go further. Chief Wabasha (Red Leaf) talked them into staying. Wabasha feared if they continued on, they would steal game along the way and eventually unite with the Objiwe in war against the Dakota (a real concern).

Eastman's orders were to get the Winnebago moving again. He saddled up with twenty-five of his men and one hundred willing Dakota. At Wabasha's Village, he met and took charge of volunteers from Wisconsin, sixty armed wagons, and horse troops.

Artist Henry Lewis showed up just in time to witness the event at Wabasha's Prairie:

On this plane [plain] were encamped about sixteen hundred indians and perhaps two hundred troops. . . . We had hardly got the line form'd when

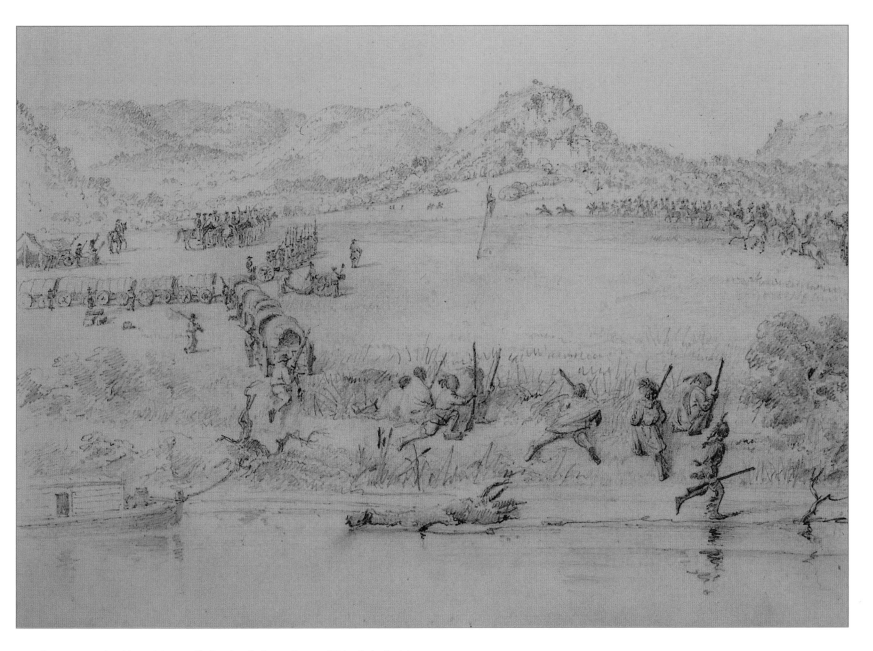

Eastman made this quick pencil sketch of the action at Wabasha's Prairie.

the indians came dashing up at full speed—to the number of eight hundred all mounted and painted and dress'd in grandstyle they would dash up . . . to the guns of the men and not finding the line give way they would wheel and ride back again yelling and shouting in most delightful style. . . . It was mainly owing to the timely arrival of Cap Eastman and the immediate steps he took knowing the indians as he did that sav'd the litt[le] army from destruction . . . I heard many councils with the chiefs at which he presided and marked that . . . he was making them think it was all for their own good and individual benefit that he was acting.

Eastman sent word to Wabasha, his men, and the Winnebago that "he would receive them gladly as friends—or if they preferred fighting, it was a matter of no consequence to him." A council was called, but the Dakota leaders who had come with Eastman were reluctant to talk in it. They had been told that Wabasha had placed a warrior with a loaded pistol behind each of them. Wabasha's men were to use their pistols if anyone spoke against his wishes.

Henry Lewis, who happened to have followed Eastman to the scene, noted in his diary:

After this council had broken up without coming to any conclusion—Cap. Eastman now call'd a council in our tent of all the Sioux and Winnebagos excepting Wabashaw and a few others. . . . This talk resulted in most of the chiefs promising to come on their journey as soon as they could get their young men to move. Things now began to look more tranquil and as the Captain and his men might be wanted at the fort to attend to the Chippewa difficulties . . . we prepared to start.

Eastman took Wabasha under arrest and accompanied the Winnebago back to the fort. Once there, the Winnebago and the Dakota feasted and danced. Arguments and rumors of Ojibwe war parties kept things from getting

dull, but Eastman handled all calmly and firmly. No wavering. No excuses. No deaths. In the end there was enough harmony to set Wabasha free. Superintendent Harvey called Eastman "a most efficient Frontier officer."

In late summer, the efficient captain was reassigned to Texas—a huge step farther from the New York art markets.

There was one chance to escape this move. The Office of Indian Affairs was publishing a major study on American Indians. The writer/researcher had already been chosen: Henry Rowe Schoolcraft, a former Indian agent in Michigan Territory. But the position of illustrator was open. Eastman applied for the assignment.

It took three months for a reply. In the meantime, he was bound for Texas. Before leaving, he painted a picture of the American Fur Company headquarters for Henry Hastings Sibley. Eastman suggested that perhaps Sibley, who was now a delegate to Congress from Minnesota Territory, could influence key people in Washington, D.C., to help him get the illustrator position.

On October 1, the Eastmans sadly left Fort Snelling and their friends, and boarded a steamboat for St. Louis. There the family split. Mary and the five children headed east (probably to her family), while Seth continued south. Mary wrote she was "quite distraught, parting with my old man."

Eastman was no happier. He was separated from his family, the art world, and his life's work.

National Indian Painter

October 1848 to August 3, 1875

A REPLY FINALLY CAME from the Office of Indian Affairs. Several esteemed painters were being considered for the Schoolcraft books, and the decision had not yet been made.

Discouraged, Eastman returned to drawing landscapes in his Texas sketchbook. He remained in the South until September, when he received a five-month leave. He hurried east to be with his family and to plead his cause to become Schoolcraft's illustrator.

While Eastman was in Texas, his reputation had surged ahead.

Mary's book *Dahcotah; or, Life and Legends of the Sioux* had been published with his illustrations, and the combination drew praise. The *Literary World* wrote, "His paintings of Indian Life are well known and much admired, and it would be well if his pencil were called into requisition for an illustrated work on a larger scale than the present."

Soon his pencil *was* called into service on a larger project. On February 27, 1850, Eastman received word that he had won the Schoolcraft position (Sibley's support may have helped). Eastman would work for the

When Minnesota became a territory in 1849, Henry Sibley asked Eastman to design a territorial seal. Eastman responded with this small, round watercolor that included a settler plowing and an Indian on horseback against the Falls of St. Anthony.

next five years, at his army pay, on 275 pages of illustrations for the six volume set: *Historical and Statistical Information Respecting the History, Conditions, and Prospects of the Indian Tribes of the United States.*

It was a massive undertaking, and Schoolcraft was a hard man to work for. He was opinionated and selfish; he was a sloppy researcher; and he had a low opinion of the peoples he was writing about. In contrast, Eastman was careful and precise in his work, gentlemanly in his manners, and genuinely interested in his subjects.

Since Eastman worked on this project in Washington, D.C., he did not have direct experience with many of the Native peoples he needed to paint. He based his work on the research and sketches of others and artifacts. And he often used his Minnesota sketches—especially of the Dakota—as a base for pictures of all Indians he did not know personally. This made these pieces less accurate.

While the Schoolcraft books were criticized for being expensive, disorganized, and too long (the first weighed ten pounds!), Eastman's illustrations were appreciated. The *Missouri Republican* reviewed the first two volumes (published in 1851 and 1852, respectively): "Eastman . . . has exercised the highest and most cultivated art in giving by brush or pencil such faithful and elegant representations of

Henry Rowe Schoolcraft

the customs, sports, villages and scenery of their country as are seen in these volumes . . . the perfect truth of these scenes can only be realized by one who has seen the originals often."

A young artist, Frank Blackwell Mayer, saw Eastman's illustrations and introduced himself. Mayer wanted to paint the Dakota at some upcoming treaty signings. Minnesota had become a territory in 1849, and settlers

were pouring in. Dakota chiefs felt pressed by food shortages, debts, the traders, and the government to sell their lands. This had been a method of U.S. policy since Thomas Jefferson had been president. He wrote of the Indians: "We shall push our trading houses and be glad to see the good and influential among them [the Indians] run into debt, because we observe that when these debts get beyond what the individuals can pay, they become willing to lop them off by a cession of lands. . . . In this way, our settlements will gradually circumscribe and approach the Indians."

Jefferson's policy worked then and was still working. In 1851, in two treaties, the eastern Dakota sold nearly twenty-four million acres. (Chief Cloud Man was one of the signers.) They agreed to live on two long reservation strips lining the St. Peter's (Minnesota) River, while keeping some hunting rights.

Frank Mayer journeyed to Minnesota Territory to paint the historic treaty councils. Eastman gave him useful advice and letters of introduction. One of the people Mayer met in Minnesota was Eastman's daughter Nancy, or Great Spirit Woman. Seth may have asked Frank to check in on her. Or perhaps Eastman suggested that she would be gracious if Frank visited. No one knows. But Frank met her and sketched her,

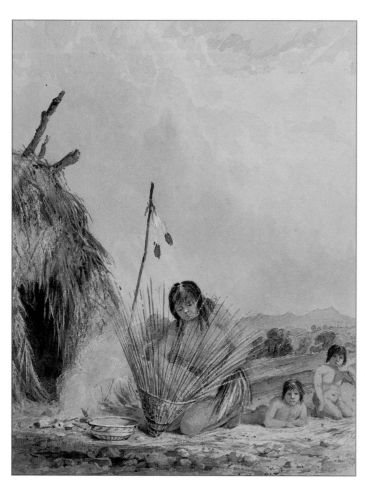

California woman making baskets, Sacramento Valley, based on a sketch by another artist, E. M. Kern

Nancy Eastman (Wakantankawin or Great Spirit Woman) by artist Frank Mayer. Nancy married a Dakota man, Many Lightnings. Their fifth and last child, Ohiyesa (Charles Eastman), would become the most prominent Native American in this country at the beginning of the twentieth century.

and seemed to be taken by her loveliness and that of the other young women he met of mixed heritage.

After Eastman's work on the Schoolcraft volumes and on Mary's books and stories, he served once more with the First Infantry in Texas. He was not pleased with this assignment. He wrote that the country where he was stationed, 255 miles north of San Antonio, was "a miserable country and no white, black or red folks in it." (Later, he discovered that the Comanche Indians did live there.) It was not long before Eastman returned to Washington, D.C., on sick leave. He had a few other assignments but nothing that held his interest.

In April 1857, Eastman was sent back to his old home—Fort Snelling. This time, though, it wasn't to command, but to survey the lands and sell the military reservation and fort. Now that the Dakota had been moved to their reservations, there was no need for the fort. Eastman estimated the number of acres and sold them to Franklin Steele, the former store sutler from the fort and Henry Sibley's brother-in-law. The cost: ninety thousand dollars or about $14 an acre.

No sooner was the sale announced than the criticism began: Eastman had not followed procedures, he had not looked at other offers, he had sold it for too little, he had sold it to a friend.

A governmental investigation followed. Eastman denied that he was any special friend of Steele's. However, he clearly had not followed the usual rules. It was an embarrassing affair, and it ate away at Eastman's declining health.

While Eastman was back in Minnesota, there is no record that he visited his daughter or grandchildren. Nor are there any family memories of such a meeting.

Nancy Eastman died the next spring, at the age of twenty-seven. She had

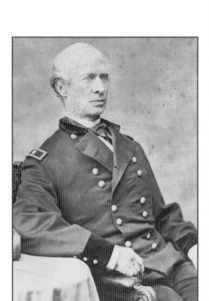

Brigadier General Seth Eastman

recently given birth to her last child: Charles Eastman, or *Ohiyesa*.

After the Steele case, Eastman worked mostly with recruits and prisons. He reached the honorary rank of brigadier general.

As for his artistic life, in 1860 he became one of the first trustees of the National Gallery and School of Arts in Washington, D C. After the Civil War, he painted nine scenes of Indian life for the committee chambers of the U.S. House of Representatives. These large-scale oils are all based on his earlier pictures from Minnesota—mostly of the Dakota.

Eastman's final work for the U. S. Capitol was to paint seventeen oils of American forts, among them Fort Snelling. His favorite, though, he saved for last, the place where he had learned to paint: West Point.

On August 31, 1875, while working on this West Point painting, he suffered a stroke. He died upon his easel.

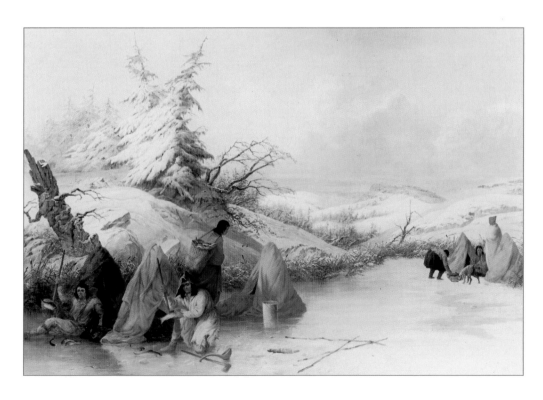

Spearing Fish in Winter was one of nine oil paintings Eastman completed for the U. S. House of Representatives

Afterword

THOUGH EASTMAN did not return to Fort Snelling after 1857, many of his Dakota kin and friends did.

The treaties of 1851 left the eastern Dakota in a poor position. They tried to live by the hunt, but game was too scarce and their lands too few. They had sold ninety percent of their land.

Each year it was the same old story. Most of the government payments went to the traders or to other whites who used the money "for the Indians." Some money was never paid at all. What money came, usually came late and was not enough for the winter. Then the cash eventually went straight back to the traders, who sold goods at exaggerated prices. Supplies sent by the government were meager and often spoiled. Other money went to white sellers of "fire-water."

Government officials and missionaries were determined to make farmers and Christians out of the Dakota. Some were willing. But many were not. So the government encouraged putting Dakota children into boarding schools. The Dakota began arguing among themselves about what was the best way to live, to survive in this changing world.

In 1858, Minnesota became a state. A former Indian agent, Alexander Ramsey, was elected governor. He supported the claims of traders, such as Henry Sibley, who took large chunks of the yearly treaty payments.

Anger rose each year as government promises were broken and hunger licked the ribs of the Dakota children. Still, the Dakota continued to try to live by their traditional ways, traveling where they could to hunt and collect sap, berries, nuts, roots, and rice.

Many new settlers disliked and feared the Dakota. Killings and robberies committed by both sides only increased the distrust.

Finally, in July 1862, the Dakota waited for their yearly payment. But the Civil War was on. The U.S. government was short of funds.

Even so, the traders had full warehouses. But they would not give credit to the Dakota. One trader said, "If they are truly hungry, let them eat grass, or their own dung."

In mid August, four Dakota warriors got into a fight over stolen eggs. They killed a whiskey seller, his wife, and three others. This grew into a war that lasted six weeks. More than 500 settlers and soldiers were killed, and by some accounts, at least as many Dakota.

Settlers fled east, and many of the Dakota fled west or into Canada.

Minnesota troops, led by Henry Sibley, pursued the warring parties, who faced them along the Minnesota River. Eventually, about 2,000 Dakota, including many women and children, surrendered. Of these, 400 were put on trial by Henry Sibley. He selected five of his military officers as judges. The Dakota were given no defense.

In the end, the names of 303 Dakota men were sent to President Abraham Lincoln to approve their death sentences. Lincoln could see justice had not been done. He refused to sign most of the execution orders. On December 26, 1862, 38 men were hanged. A few of these individuals were known to have actually tried to stop the killing or save some white settlers' lives. This was the largest mass hanging in U.S history.

About 1,200 Dakota were imprisoned in a stockade built along the rivers below Fort Snelling. That winter, disease and hunger killed at least 130. Chief Cloud Man, who had opposed the fighting, was among them. The place that had once been a center for friendship and trade had become an internment camp.

Later, the Dakota families at the fort were transferred by steamboats to Crow Creek, South Dakota. After three years of failed farming and many more deaths, the remaining survivors were moved again. This time they traveled south to the Santee Reservation in Nebraska.

Eastman had to have heard about all that happened. But he left no clue about how he felt about it. In many ways, he had seen it coming—not the war necessarily, but the end of the life that the Dakota had known. That is why he had worked with such dedication to preserve it on paper and canvas, so it would not be forgotten. In this he succeeded.

Epilogue

EASTMAN'S DAKOTA FAMILY fled to Canada. Ohiyesa, with his grandmother, uncle, and some other members of his family, lived there according to Dakota ways. His father, Many Lightnings, was captured in Winnipeg, Manitoba. He was transported back to Fort Snelling, where he was imprisoned. (Chiefs Little Six , or Shakpay, and Medicine Bottle were also caught. These two were hanged, again with little defense.)

Many Lightnings was then transferred to Camp McClellan, a federal prison near Davenport, Iowa. About 250 other Dakota people were held captive there. They were taught to read and write in Dakota. They were urged to be baptized and to learn to farm. And they were pressed to give up their Dakota ways.

Many Lightnings learned farming and was baptized Jacob. He took his wife's last name: Eastman. His two eldest sons, who were with him in camp, became John and David Eastman. Eventually, everyone in the camp was pardoned and sent to Nebraska.

After some time, Indians who were willing to farm were allowed to go in search of land to homestead, or stake a claim for a farm. Jacob Eastman and his family were part of a group who traveled to Flandreau, South Dakota. Flandreau is in the state's southeast corner, as close as one can settle to the Pipestone area in Minnesota without crossing the state line. Pipestone is a sacred place for the Dakota, the source of the red stone used for pipes of peace. One Dakota man explained: "This pipe is a part of our flesh. The red men are a part of the red stone." Many Lightnings had come home.

In September 1872, Jacob journeyed to Canada in search of his two remaining sons. One had been adopted by a Canadian trader. But Jacob found

his youngest son, fifteen-year-old Ohiyesa. Ohiyesa returned with his father and was baptized Charles Alexander Eastman.

He studied at the mission school in Flandreau, then worked his way through two western colleges. He went on to graduate from Dartmouth and the medical department of Boston University. The new Dr. Eastman returned to the place of his birth and practiced medicine in St. Paul. Then he spent some years attending his people on their reservation in South Dakota. He later became a prominent leader in the Boy Scouts, sharing his knowledge of woodcraft and wildlife. His friends included many prominent Americans, such as Theodore Roosevelt and Mark Twain. Charles, like his grandfather Seth Eastman, wanted to document the traditional ways of the Dakota. He wrote several books, one entitled *Indian Boyhood.*

Charles Eastman was just one of many Dakota who returned to their homelands. The eastern Dakota kept straggling back to Minnesota whenever they could, however they could. Today, there are Mdewakantonwan communities at Prairie Island, Mendota, and Shakopee, and other places in their traditional lands. Other communities of the Dakota's Oceti Sakowin exist in the Minnesota River Valley, especially at the Upper and Lower Sioux Reservations.

Seth Eastman has many Dakota kin alive today. Though he did not fully honor his Dakota family relations while he was living, he did leave them a legacy in his paintings. These paintings, because of their accuracy and detail, give us a glimpse into the daily lives of the Dakota of the 1830s and 1840s and the landscapes that were theirs.

And they give the eastern Dakota a snapshot album to carry with them as they bring together new ways and old ways in the twenty-first century.

This portrait of *Dr. Charles Eastman, "Ohiyesa," Class of 1887 at Dartmouth College,* was a gift to the school from his classmates.

Timeline of Seth Eastman's Life ——————————

1808 January 24: Born in Brunswick, Maine

1824 July 1: Enrolls as cadet at the United States Military Academy at West Point, New York, along the Hudson River

1829 July 1: Graduates from West Point, commissioned as an officer, second lieutenant, and is assigned to the United States Army's First Infantry Regiment
 October: Serves at Fort Crawford, Wisconsin, along the Mississippi

1830 February 2: Reports for duty at Fort Snelling, in Unorganized Territory, eventually to become Minnesota
 Marries Stands Sacred (Wakaninajinwin) according to Dakota ways

1831 March or April: Daughter is born, Winona, later known as Nancy or Mary Nancy Eastman or Great Spirit Woman (Wakantankawin)

1832 January 19: Leaves Fort Snelling for duty in the Topographical Bureau in Louisiana

1832 August 6: Transferred to topographical duty in Connecticut

1833 January 9: Receives orders to return to West Point as assistant drawing teacher.
 While at West Point, studies first under Charles R. Leslie and then under
 Robert W. Weir

1835 Marries Mary Henderson, possibly in a double ceremony on June 9, when Mary's sister Sarah married another assistant teacher at West Point, Francis H. Smith, a friend of Eastman

1836 Promoted to first lieutenant. First son, Robert Langdon, is born

1836–40 Exhibits landscape paintings annually at the National Academy of Design, in New York City; elected "honorary member amateur" in 1838. Two more children born, Thomas Henderson and Virginia Henderson Eastman

1837 *Treatise on Topography,* written and illustrated by Eastman, published; becomes required textbook at West Point

1839 Promoted to captain. Invited to teach at Jefferson College, but declines. Exhibits at New York gallery. Transferred to active duty on war front in Florida Territory, fighting the Seminoles

1841	June: Transferred to Norfolk, Virginia, to recover from tropical illness contracted in Florida September 30: Returns to Fort Snelling to command Company D, First Infantry
1841–48	Post commander at Fort Snelling four times, longest period (17 months) in 1847–48. Exhibits Indian paintings and landscapes with National Academy of Design, American Art Union, and Western Art Union. Gains reputation as soldier-artist. Two more children born, Franklin Smith and Mac Henderson Eastman
1848	October 1: Leaves Fort Snelling with Company D for duty in Texas
1849–55	In Washington, D. C., first on furlough, then as artist for the Office of Indian Affairs, working on drawings for the 300 plates to illustrate Henry Schoolcraft's *Indian Tribes of the United States*. Another son is born
1856	Promoted to major
1857	April–May: Surveys and sells lands for the Fort Snelling Military Reservation to Henry Sibley's brother-in-law, Franklin Steele. Receives reprimand following investigation
1858–63	Assigned to short stints on frontier, recruiting, prison command, and special duties
1860	Becomes one of the first trustees of National Gallery and School of Arts in Washington, D. C.
1863	December 3: Retires because of failing health, but remains on active list for recruitment station command duties
1866	August 9: Reaches rank of colonel and honorary brigadier general
1867	March 26: Commissioned by Congress to paint pictures of American Indians for the chambers of the House Committee on Indian Affairs in the U.S. Capitol
1870	June: Commissioned by Congress to paint 17 pictures of U.S. forts for the chambers of the House Committee on Military Affairs
1875	August 31: Dies at home in Washington, D. C., while at work on a painting of West Point

About the Paintings

SETH EASTMAN originally created most of the watercolor paintings pictured in *PAINTING THE DAKOTA: Seth Eastman at Fort Snelling* for Henry Rowe Schoolcraft's six-volume work, *Historical and Statistical Information Respecting the History, Conditions, and Prospects of the Indian Tribes of the United States.* This monumental study was published by the U.S. government, one book at a time, beginning in 1851. The series was completed six years later, with volume six, in 1857.

Eastman based many of his illustrations on sketches he had made in Minnesota. As a career army officer assigned to Fort Snelling, he was in a unique position to record Indian life. His portfolio included scenes of winter villages and temporary summer encampments, courting and marriage customs, Indians making maple sugar, protecting their cornfields from birds, spearing fish, and gathering wild rice.

A few of the other paintings in *PAINTING THE DAKOTA* were watercolor illustrations Eastman made for books about Native American life written by his wife Mary Henderson Eastman (including *DAHCOTAH; or, Life and Legends of the Sioux Around Fort Snelling,* published in Philadelphia in 1849). These pictures include *The Laughing Waters* (p. 28), which depicts Minnehaha Falls in Minneapolis, and *Indian Courting* (p. 23), in which a young man plays a melody on a wooden flute.

Eventually, some years following the publication of the Schoolcraft volumes and Mary Eastman's books, Seth Eastman or his family sold the original watercolor illustrations. Fifty-six of these paintings were purchased by railroad builder James J. Hill. Known as the "Empire Builder," Hill was Minnesota's most prominent citizen in the late nineteenth and early twentieth centuries. In 1893 his Great Northern Railroad linked St. Paul with

Seattle. Two years earlier he had moved his family to a huge stone mansion on Summit Avenue in St. Paul.

Like many other wealthy men of his time, James J. Hill collected art. His family mansion included a gallery where he displayed his European paintings and sculpture. This is almost certainly where he also kept the Eastman paintings. Unlike his European paintings, the watercolors were not framed nor hung on the walls. Instead, like other works of art on paper Hill owned, they were probably laid flat on shelves from which they could be pulled and studied.

One of Hill's granddaughters, Georgiana Slade Reny, recalled a game she had played with her grandfather in the gallery as a child. He had given her a magnifying glass, she told relatives, and challenged her to find certain Indians or Indians performing various tasks. The Eastman paintings were, of course, ideal for this kind of search. Their elaborate detail would have provided good hunting grounds for a young explorer.

After James J. Hill died in 1916, the Eastman paintings were moved to the James J. Hill Reference Library in downtown St. Paul. Hill had delighted in building this library during his last years to house some of his precious personal books and collections. He had also prepared lists of other worthwhile books for his new library. Serious reference libraries were then few and far between, and his goal was to provide scholars with books that contributed to human knowledge and progress, especially on philosophy and science subjects. The James J. Hill Reference Library was the railroad builder's most enduring gift to the people of St. Paul.

In 1994, after having safeguarded the paintings for more than seven decades, the Hill Library decided to sell its Eastman watercolors. The paintings had been kept largely under wraps in recent years, locked in a safe at the Hill Library, because they had become quite valuable. The money from

the sale of the paintings could be used to help support the library. Art auctioneer Sotheby's appraised the fifty-six paintings at more one million dollars, and they were purchased by W. Duncan MacMillan of Wayzata, Minnesota.

With the Eastman paintings now in private hands, they are more available to more people than ever before. MacMillan is president of the Afton Historical Society Press, which in 1995 published the entire collection in full color in a large, 12" x 12" book, *SETH EASTMAN: A Portfolio of North American Indians* by Sarah E. Boehme, Christian F. Feest, and Patricia Condon Johnston. As a companion book, Afton also reprinted Mary Henderson Eastman's *DAHCOTAH; or, Life and Legends of the Sioux Around Fort Snelling*. Publication of these two books was celebrated with an exhibition of the paintings at the Minneapolis Institute of Arts.

The publication of
PAINTING THE DAKOTA: Seth Eastman at Fort Snelling
coincides with an exhibition of the
MacMillan Collection of Seth Eastman watercolor paintings
at the Smithsonian's National Museum
of the American Indian in New York,
as well as a new public television documentary based on
SETH EASTMAN: A Portfolio of North American Indians,
coproduced by Afton Historical Society Press
and Twin Cities Public Television.

List of Illustrations

Unless otherwise noted, the drawings, paintings, and photographs in this book are reproduced courtesy of W. Duncan MacMillan, who in 1994 purchased the former James J. Hill Collection of Seth Eastman watercolors from the James J. Hill Reference Library in St. Paul, Minnesota.

Bibliography

Anderson, Gary Clayton. *Kinsmen of Another Kind: Dakota-White Relations in the Upper Mississippi Valley, 1650–1862* (1984; St. Paul: Minnesota Historical Society Press, Borealis Books, 1997).

Beane, William L. *Eastman, Cloud Man, Many Lightnings: An Anglo Dakota Family History* (Lincoln, Nebr.: William L. Beane, 1989).

Beane, William; phone interviews and email correspondence with author, October, November 1999, January 2000, notes in author's possession.

Beck, Roger Lawrence. *Military Music at Fort Snelling, Minnesota, from 1819 to 1858: An Archival Study,* (Ph. D. thesis, University of Minnesota, 1987).

Boehme, Sarah E., Christian F. Feest, and Patricia Condon Johnston. *Seth Eastman: A Portfolio of North American Indians* (Afton, Minn.: Afton Historical Society Press, 1995).

Dippie, Brian W. *Catlin and His Contemporaries: The Politics of Patronage* (Lincoln: University of Nebraska Press, 1990).

Durand, Paul. *Where the Waters Gather and the Rivers Meet: An Atlas of the Eastern Sioux* (Prior Lake, Minn: Paul C. Durand, 1994).

Eastman, Charles. *Indian Boyhood* (New York: Dover Publications, 1971. Originally published 1902 by McClure, Phillips & Company).

_____. letter to H. M. Hitchcock, September 8, 1927, copy courtesy of ancestor William Beane.

Eastman, Mary. *Dahcotah; or, Life and Legends of the Sioux* (Afton: Afton Historical Society Press, 1995; first published New York: John Wiley, 1849) with paintings by Seth Eastman.

Hall, Steve. *Fort Snelling, Colossus of the Wilderness* (St. Paul: Minnesota Historical Society Press, 1987).

Hansen, Marcus L. *Old Fort Snelling, 1819–1858* (Iowa City: State Historical Society of Iowa, 1918).

Hitchcock, H.M., "An Indian Returns Home," *Minneapolis Journal*, September 28, 1930.

Kozlak, Chet. *Dakota Indians Coloring Book*, drawings by Chet Kozlak (St. Paul: Minnesota Historical Society Press, 1979). Translations by Elsie M. Cavender, Evelyn M. Prescott, Lorraine Cavender-Gouge, Mary C. Riley.

McDermott, John Francis. *Seth Eastman: Pictorial Historian of the Indian* (Norman: University of Oklahoma Press, 1961).

_____. *Seth Eastman's Mississippi: A Lost Portfolio Recovered* (Urbana: University of Illinois Press, 1973).

McReynolds, Edwin C. *The Seminoles* (Norman: University of Oklahoma Press, 1957).

Meier, Peg. *Bring Warm Clothes: Letters and Photos from Minnesota's Past* (Minneapolis: Neighbors Publishing, 1981).

Minnesota Historical Society, *Historic Fort Snelling* site brochure.

Pond, Samuel W. *The Dakota or Sioux in Minnesota as They Were in 1834* (1908, St. Paul: Minnesota Historical Society Press, Borealis Books, 1986).

Spector, Janet D. *What This Awl Means: Feminist Archaeology at a Wapeton Dakota Village* (St. Paul: Minnesota Historical Society Press, 1993).

Marybeth Lorbiecki has a master's degree in English and has taught students of all ages. She is especially attracted to researching and writing about topics that help one understand the inner workings of the land and the human heart. Her picture book, *Sister Anne's Hands,* was acclaimed by *USA Today* and won numerous honors, including the "Living the Dream" Award, a children's choice award that annually highlights one book that fosters the realization of the Martin Luther King, Jr., ideal. Her children's biography of Aldo Leopold, *Of Things Natural, Wild, and Free,* was chosen as a John Burrough's Nature Book and awarded a Distinguished Service to History Award from the State Historical Society of Wisconsin. Her adult biography, *Aldo Leopold: A Fierce Green* Fire, won a Minnesota Book Award for biography and history and also the Distinguished Service to History Award from the State Historical Society of Wisconsin.

Lorbiecki lives in Hudson, Wisconsin, with her husband, David Mataya, and their three young children—Nadja, Mirjana, and Dmitri. She is at work on numerous book projects and awaits the publication of several picture books scheduled for 2002 and 2003.

Lori K. Crowchild, a member of the Shakopee Mdewakanton Dakota Community (SMDC) is of Dakota, Ojibwe, and EuroAmerican descent. She earned a bachelor of arts degree in nursing from the College of St. Catherine and completed graduate studies in public health at the University of Minnesota. While working in the health field, her most rewarding efforts were in sharing HIV/AIDS prevention information with Native American communities across the United States. She now serves on the Minnesota American Indian AIDS Task Force Board of Directors.

Lori is co-owner of Allies: media/art, a Dakota owned media production company. Through Allies, Lori and her business partner, Mona Smith (Sisseton Wahpeton), strive to increase awareness and understanding regarding Native American people, communities, and issues, while recruiting and promoting Native American artists. In January 2000, Lori was elected to a four year term as Secretary/Treasurer by the SMDC.

Acknowledgments

THANK YOU to Afton Historical Society Press publisher Patricia Condon Johnston who encouraged me to tackle this project; to W. Duncan MacMillan who preserved the integrity of the James J. Hill Collection of Seth Eastman paintings and helped make this book possible; to Lori K. Crowchild for her Foreword; to William L. Beane, great-great-great grandson of Seth Eastman and Stands Sacred for his invaluable assistance and persistent attention to details and Dakota language; to Alan R. Woolworth, Research Fellow Emeritus of the Minnesota Historical Society; to Thomas Shaw, assistant site manager at Historic Fort Snelling; to the Shakopee Mdewakanton Sioux Community; to the Smithsonian Institution; to Twin Cities Public Television; to Mary Beth Nierengarten, Paula Schanilec, Valerie Thompson, and Julie Dunlap for manuscript assistance; to Melissa, Mariah, and Denise Snow for taking such good care of my children while I was working; and to my family without whom nothing would be possible: my husband, David, and my incredible kids: Nadja, Mirjana, and Dmitri.

M. L.

Index

Bold numbers indicate pages on which an illustration appears